Contents

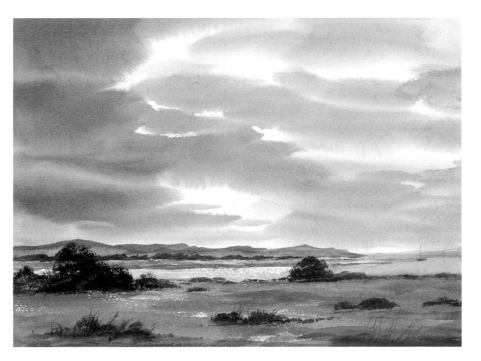

Page 1: **Walking the Dog,** 31 x 41 cm (12 x 16 in)
Opposite: **Sunny Morning, Winter 1998,** 27 x 34 cm (10½ x 13 in)
This page: **The River Mouth,** 31 x 41 cm (12 x 16 in)

Portrait of an Artist

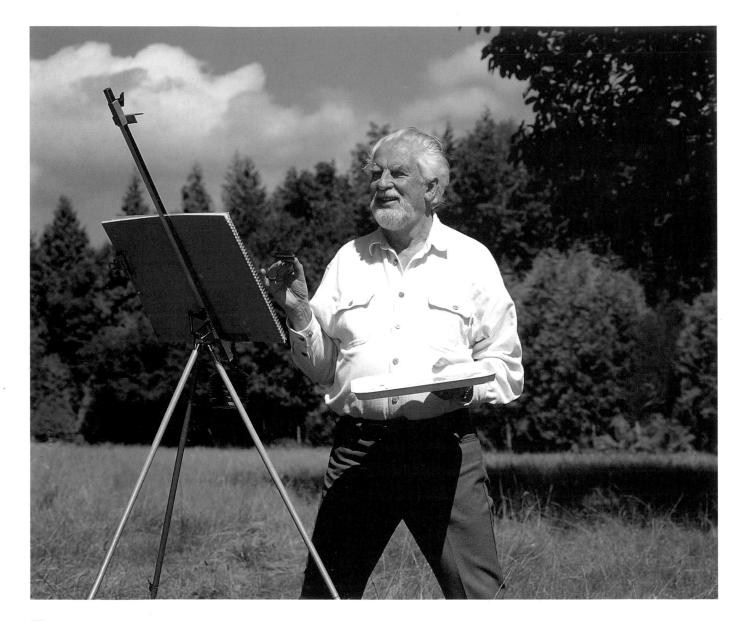

Born in Chesterfield in 1925, Ron Ranson's first career was in engineering. He began as an apprentice with Rolls Royce in Derby, and later moved on to technical writing and illustration. Having always been interested in design, he decided to go into the world of advertising, working as a visualiser. On reaching the age of 38, he decided it was time to try something different again, and became a publicity manager for an engineering firm.

This took him all over the world, designing and erecting exhibition stands in such places as Moscow, Teheran, and Lagos. After 12 years, a take-over bid put him back into the job market. The next change marked the beginning of what was to become an incredible success story.

Not wanting to go back into industry, Ron decided to take a chance and break into the world of art, reviving early skills from school

▲ Ron at work on one of his dramatic skies.

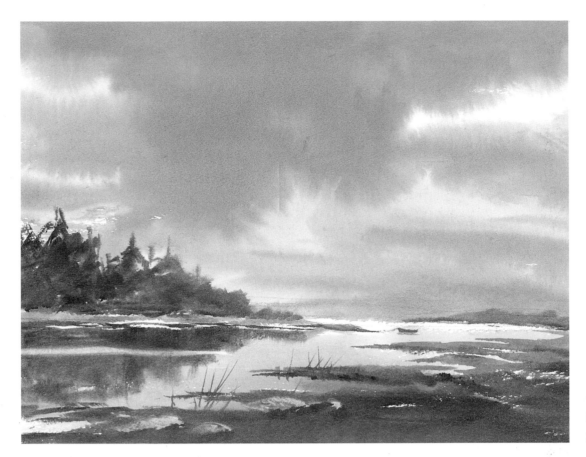

◀ **Low Clouds
Over the Estuary**
29 x 40 cm (11½ x 15½ in)

days. Specializing in watercolour, his paintings began to sell almost immediately. He soon discovered latent skills in teaching and writing and his career was established. By the mid 1970s, 'Wye Valley Watercolour Weekends' was well and truly launched, and soon students from all over the world were arriving in the tiny village of St. Briavels.

Having written for *Leisure Painter* magazine, Ron took the articles to a publisher who commissioned him to write *Watercolour Painting – The Ron Ranson Technique.* The book became a best-seller world-wide, and so another aspect of his career was born. A prolific writer, he now has some 25 titles to his credit, including his latest HarperCollins success, *Watercolour Landscapes from Photographs.* Videos were the next departure. A pioneer of this new medium, he soon found his videos selling too, both at home and abroad.

All this activity brought requests from students as far afield as Australia, America and South Africa for Ron to teach in their own countries, and so began his foreign workshop tours that are now such a feature of his life. Much of his work at present is done in European countries, such as Norway, Holland, Italy, Greece and France.

America welcomed Ron with open arms; his workshops there are always filled to capacity and his books sell as quickly as they are printed. However, according to Ron, the best thing about America was that it produced his wife, Darlis, whom he found in Oregon on one of his painting workshops. In his usual dynamic way, he courted and married her, sweeping her off to England within two short months.

His articles for *Australian Artist* magazine led to him being offered the prestigious position of European editor of the *International Artist Magazine* – a challenge which he found impossible to refuse and which has vastly widened his sphere of activity and influence. Ron is a happy man, enjoying all the excitement and stimulation of a flourishing career.

Painting Atmospheric Skies

Without doubt, painting skies is one of my greatest joys. Like everything else worth doing, creating authentic skies will require practice while you are learning the new skills you need, but you'll soon find that all the effort you have put in will be well rewarded. You'll notice that your painting will take on vitality, excitement and atmosphere, giving endless satisfaction, not only to you, but to your viewers.

However, it does seem to me that skies are the most neglected area of landscape painting. So much time is spent learning how to paint trees, rivers and buildings that the sky is often just filled in as an afterthought. This is strange when you consider that the sky is not only an integral part of the landscape, but actually affects the whole scene below it. Many teachers of watercolour, both in their workshops and in the instructional books they write, leave too little time or space to explore this important aspect of creating convincing and memorable paintings.

Changing the mood

If you look at the two illustrations on these pages and then imagine the weather conditions reversed, both pictures would change dramatically. None of the main features would be removed and yet the whole scene would present an altered aspect.

For an element that is always with us, most of us know appallingly little about skies. Cloud types are generally unknown, and without at least basic knowledge, convincing skies in your paintings are unattainable. The good news is that the techniques you need for painting skies are easily learned, and watercolour is the ideal medium to use.

▼ More Snow on the Way
31 x 41 cm (12 x 16 in)
This is a scene of contrasts. The softly painted, wet-into-wet sky, threatening snow, contrasts with the crisp trees in the middle distance. The snow, represented by the white of the paper, is highlighted against the dark foreground rocks.

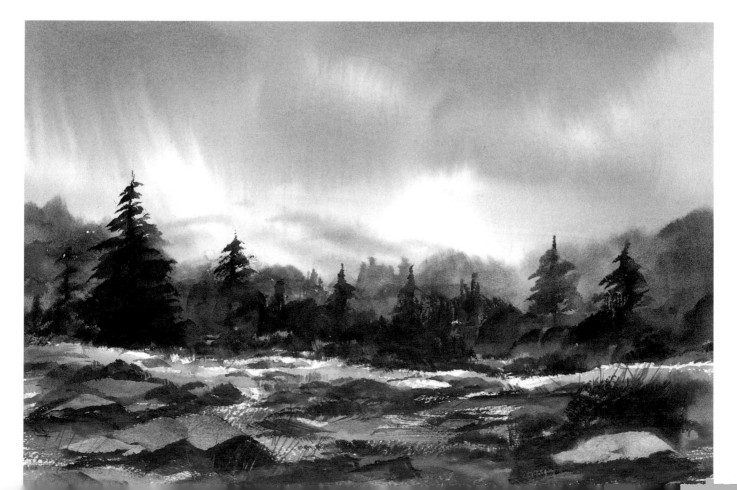

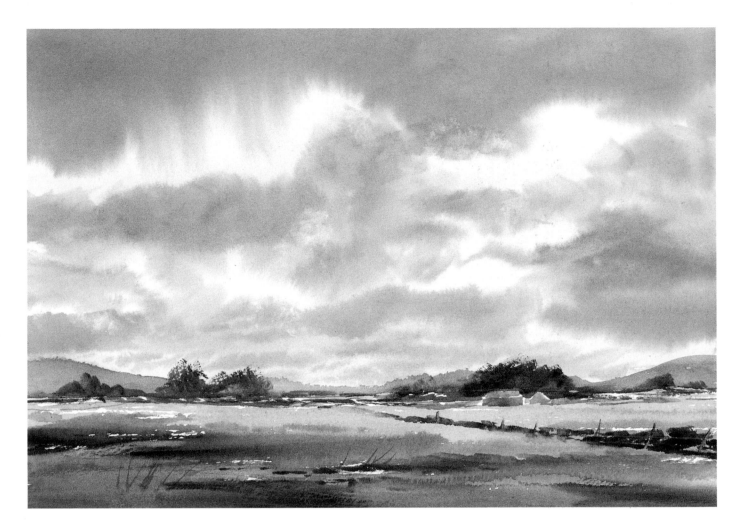

Achieving atmosphere

In this book, I'm hoping first of all to show you the basic cloud types and then, by example and instruction, to help you achieve atmospheric skies that will enhance the whole of your landscape painting. To be honest, 90 per cent of the secret is the water content of your brush, and this is a practical exercise that can easily be learned. Once you've mastered the technique, there is nothing like the pleasure of watching a watercolour sky materialising in front of your eyes. The other 10 per cent is to avoid at all costs overworking, which produces muddy, tired skies. My constant cry in my workshops is: 'Leave it alone! Let the watercolour work by itself.'

Having helped hundreds of students in the past through my workshops, I have no doubt that you, too, will succeed in painting skies. What you do need is plenty of practice. Use the backs of some of your less successful paintings. Be courageous – this isn't a time for timidity.

On the next two pages, I'm going to give you basic information on cloud types, and throughout the rest of the book, I will try to cover all other aspects of painting watercolour skies. Read the book, then have a go.

▲ **Cumulus over the Fields**
29 x 40 cm (11½ x 15½ in)
White, fluffy cumulus clouds are exciting as they move majestically over the landscape. Notice how the sky colour is repeated in the foreground.

The more emotionally involved you are with your painting, the more successful you will be.

Understanding Skies

You don't have to be a meteorologist to paint convincing skies, but you will require a basic knowledge of the most usual cloud types. The skies above us are constantly changing, presenting artists with quite a challenge. However, it is this constant change that has provided inspiration for landscape and seascape painters over the centuries.

Cloud formations

Although there are about ten major cloud formations, it isn't necessary for you to become closely involved with all of them – though having said that, there is always the danger that you will get hooked and want to learn more and more! The basic cloud formations that, as a painter, you really do need to know about are only four. Their names, derived from the Latin, also act as descriptions and are as follows:

> Cumulus: Heap
> Cirrus: Fringe or thread
> Stratus: Layer
> Nimbus: Rain

Once you have identified these four (and you'll get help with recognition from the photographs shown here) and become familiar with them, you'll find skies increasingly fascinating. Of course, you're seldom going to be able to look up and find one perfectly illustrated cloud form in an otherwise clear sky. Most of the time, you will see the various cloud types overlapping at their different levels. Even so, you'll be able to pick out the basic four quite easily.

Cumulus

If you look up and see these fluffy 'cotton wool' clouds in a blue sky, you've no excuse not to go out and paint them, as they are

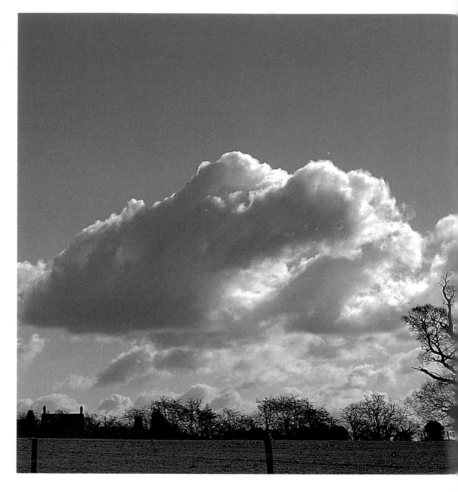

▲ Cumulus

indicators of fair weather with no immediate change. Perhaps the most important thing to remember about them is that they have rounded tops and flatter bottoms. When painting these clouds, be aware that perspective is well defined, with the clouds rapidly getting smaller as they reach the horizon. Their shape is moulded by the light of the sun, the tops often being brilliant white, while the base is in subtle shadow – very exciting to paint.

Cirrus

These feathery clouds, often called 'mares' tails', appear high in a blue sky. At about 9,000 metres (30,000 feet), cirrus is the

▲ Cirrus

▲ Stratus

highest cloud form, perhaps looking at its best in the evening in the dying rays of the sun. A different form of cirrus is sometimes seen in the light, delicate ripples known as a 'mackerel sky'. In painting cirrus clouds, a subtle and delicate touch is required – they can be used to great advantage when contrasted with stronger, more dramatic cumulus clouds beneath them. This cloud type is very useful in breaking up the monotony of a plain blue sky without being dominant and distracting from the rest of the painting.

Stratus

The most obvious characteristic of stratus is its horizontal, layered appearance, with the clouds continuing into the distance in diminishing rows. The light source is often visible and can produce dramatic effects, particularly when shafts of light shine through gaps in the cloud. If the sun is visible through the cloud, its outline can be clearly seen. In a painting, the light source can be used to avoid monotony of colour.

Nimbus

▲ Nimbus

These clouds actually come in two forms. One is the cumulo-nimbus cloud, which is heavy and dense, and either extends horizontally or forms huge towers. The other, known as nimbo-stratus, forms a grey cloud layer. As both these clouds usually indicate that it is raining or snowing, they're probably best viewed from inside.

Nimbus are the darkest and heaviest cloud forms, but even so, you must take care not to make them too dark in your paintings. This is because the landscape beneath always appears darker than the clouds themselves, and so you would end up with a painting devoid of form and colour.

Materials and Equipment

Going into an art shop can be rather like a visit to a sweet shop for a child. It is tempting to believe that, if one could buy that special brush or that particular colour, one's paintings would be instantly and magically transformed into masterpieces. However, I know in my heart that the fewer materials I have, the easier and more convenient it is to work.

Watercolour paints

First, let me explain the various forms and qualities of watercolour that are available. You can buy it in pans or in tubes. Pans are compact and handy for sketching on location,

especially when using small brushes. However, I prefer the tubes, which can be squeezed out freshly for each piece of work and are more convenient for my 'big brush' method of painting.

Both pans and tubes can be obtained in artists' and students' quality from Daler-Rowney. As a beginner, you may prefer to use students' quality at first, later progressing to the artists' quality. Of course, both are interchangeable and can be used together.

I generally restrict my own palette to eight colours and I suggest you do the same, although personal choice comes into this and I'm not being dictatorial about the actual selection. My basic colours are Raw

▲ This shows my basic painting equipment, including a selection of watercolour paints in tubes and pans, some of my favourite brushes, a plastic butcher's tray and a water pot.

▼ Tubes of Daler-Rowney's Artists' Quality paint.

Watercolour inevitably fades back slightly as it dries, so be bolder when you are laying your washes to allow for this.

Sienna, Payne's Grey, French Ultramarine, Lemon Yellow, Burnt Umber, Light Red, Crimson Alizarin, and a cool blue, such as Prussian Blue.

Before talking about brushes, I feel I should mention my painting palette, which is a simple butcher's tray made of plastic. It has no compartments, so you don't get a lot of dry, 'dead' paint lying around and it's so much easier to clean. You also have plenty of room to mix your paints.

Brushes

Daler-Rowney produce a large number of brushes, from the more expensive sable brushes to the popular synthetics, which I have always found perfectly satisfactory. One of the synthetic ranges, which I use regularly, is called Dalon.

For the exercises in this book, I suggest that you try using the same brushes as I do. The brush I use for most of my painting is the hake – a traditional Japanese brush made from goat hair. It will feel too large and clumsy at first and will inevitably take practice to handle, but you will soon come to love it and find it invaluable for producing free, fluid skies (every sky in this book is produced with the hake).

The second brush is a 25 mm (1 in) flat synthetic. When wet, it has a knife edge and is ideal for depicting buildings, boats and anything angular. The third brush is a No. 2 rigger, whose fine tip is perfect for indicating figures and all the calligraphic detail in your painting. An additional brush that I occasionally use is a squirrel hair brush, which I find particularly suitable for painting foliage and flowers. You will find all of these brushes in the Daler-Rowney range.

▼ My four brushes: from left to right, No. 2 rigger; 25 mm (1 in) flat; hake; squirrel hair brush.

Paper

Watercolour paper comes in a wide selection of makes, weights and textures. The most commonly used texture is Not or Cold-Pressed, which is ideal for landscape painting. Two alternative surface textures are Rough, which has a more pitted surface useful for strong textural effects, and Hot-Pressed, which has a very smooth surface and is more suitable for highly detailed work.

My preference is for 300 gsm (140 lb) paper that has a medium tooth. Also available are weights ranging from 190 gsm (90 lb) to 640 gsm (300 lb). The lighter weights of paper will always need to be stretched, which personally I find rather irksome. The process entails soaking the paper in water, placing it on a board and securing it with gummed tape, then leaving it to dry before use.

Most of my own paintings are done on Bockingford paper, which is available in spiral-bound pads in various sizes. These pads are easy to carry around, don't need stretching and avoid the necessity for tape and drawing pins.

Miscellaneous items

Some other very important materials are a small sketchbook, together with a range of 2B to 6B pencils or sticks of charcoal to carry out preliminary sketches and design work. In addition, you'll need plenty of rags and a plastic eraser, which is soft and kind to watercolour paper. A piece of hardboard cut to the same size as your pads will help to support them. Keep a few Stanley-knife blades to hand – their sharp points can be used with great discretion to scratch away paint to provide distant sails and masts, for

◀ The sketching materials shown here include spiral-bound sketchbooks in various sizes, as well as a range of soft pencils and stick charcoal.

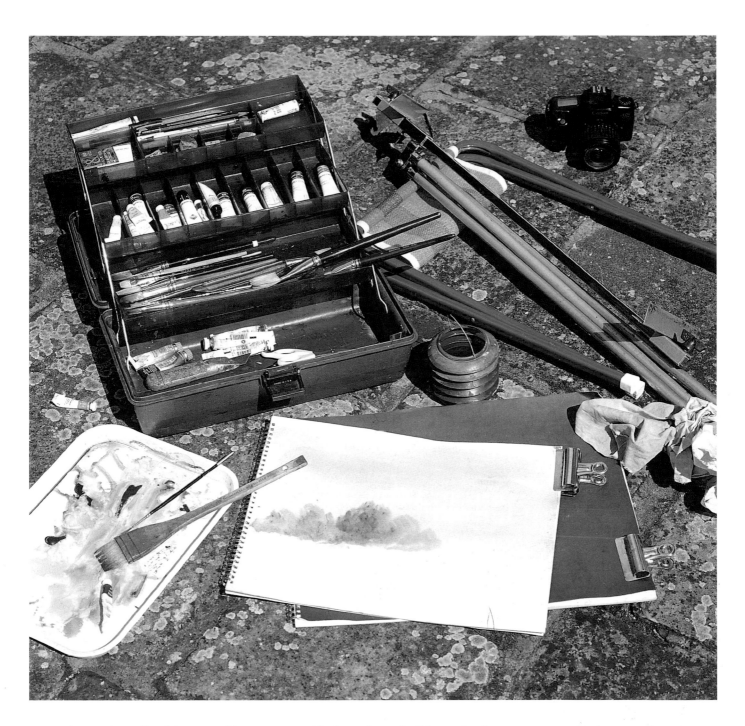

example. Masking fluid (a type of fast-drying rubber solution) is useful for certain watercolour effects.

Outdoor kit

When going painting on location, I take my folding metal easel, which is very adaptable and can be adjusted to all sorts of angles suitable for standing up or sitting down. It even comes to pieces to fit into my case, so is ideal to take on holiday. I also have a collapsible plastic water container, which hangs on my easel.

My portable plastic art bin contains all my paints, brushes, water bottles and other equipment, together with my little camera, which I always have with me when working away from home. Everything, including my easel, palette, pad and art bin, can be carried under one arm, leaving the other one free to open and close gates – the simpler the better.

▲ My outdoor kit includes a folding metal easel and seat, an art bin and a small camera.

Watercolour Techniques

Painting skies is all about applying washes, and most of the problems you will encounter will be involved with getting the water content right. Not only the water content of your brush at the time of application, but the amount of dampness still left on the paper when you put on the next wash – in other words, timing. This is not something that will take months to achieve, but you won't learn just by reading about it. It is something that needs practical application.

When teaching, I usually find that my students master the water content/timing problem in about an hour-and-a-half. Like ice skating and riding a bike, it may look impossible, but a little application and a few falls work wonders! All that is needed in addition is confidence, and this again you will only acquire through practice.

Working wet-into-wet

You will find the hake brush ideal for skies, as it covers the paper so quickly and delicately. Practise with the brush, using it as lightly as possible and working with your whole arm rather than just from the wrist. I have provided a few examples of sky mixtures on these pages for you to copy, so that you can get the feel of applying the washes. Don't expect to be able to reproduce them exactly; this is impossible. Instead, use them to help you to understand the wet-into-wet technique.

When using wet-into-wet, it's necessary to work on a slope, so that the washes flow into one another. Try various angles for different

▲ To create a straight-forward graduated sky, put on an overall wash of watery Raw Sienna, followed immediately by a wash of French Ultramarine across the top. Gradually take the pressure off the brush as you work downwards with the Ultramarine.

▶ To get this effect, you'll need a pale Raw Sienna wash again, strengthened at the bottom with Lemon Yellow. The clouds are formed by dropping in a mix of Payne's Grey and Crimson Alizarin and allowing this to blend with the initial wash.

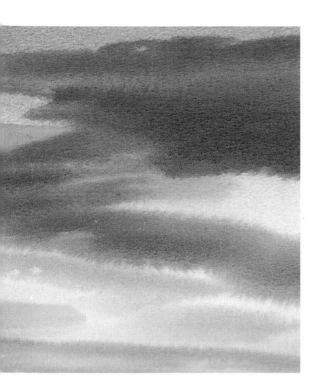

◀ For this sky, graduate some blue over the usual pale Raw Sienna wash at the top and put in a mix of Crimson Alizarin and Lemon Yellow at the bottom. Immediately drop in a strong mixture of Payne's Grey and Crimson Alizarin for the dark clouds.

▲ After your pale Raw Sienna wash, paint around the cloud shapes with Prussian Blue, leaving the first wash to show through. Now paint in the dark clouds with Payne's Grey and Crimson Alizarin.

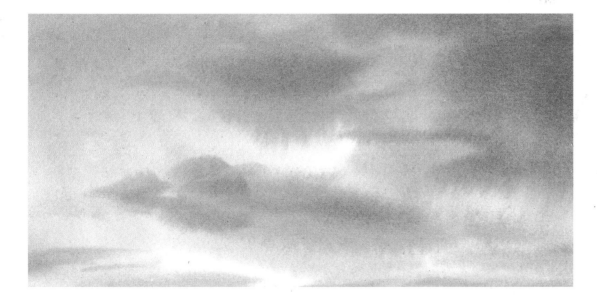

▲ A slightly more ambitious sky here, using the usual Raw Sienna followed by French Ultramarine in the top left-hand corner, and blending Lemon Yellow and Crimson Alizarin at the bottom. Put in the darker clouds with Payne's Grey and Crimson Alizarin.

effects – the exercises shown here were carried out on a 45 degree slope, allowing gravity to help! Put a first wash on your paper with very weak paint. Then dry your brush, mix some rich, strong paint and apply it immediately on top of the first, still damp, wash. Then stand back and watch what happens!

One of the most important things to remember is to compensate for the dampness already on the paper from your first wash. To do this, you must make your second

application thicker and richer than you would consider necessary. Frighten yourself when you put the paint on. It probably won't look right at first, but after about a minute, as it softens and diffuses, you will see authentic cloud shapes appearing. All very exciting and rewarding!

Don't attempt to complete a painting here – simply regard these exercises as an experiment in judging water content. You will learn more through trial and error than any other way.

◀ Try copying the four little vignettes on this page, using only the hake brush. Experiment, bearing in mind the water content of the brush.

a Drop in the reflection of the tree while the water area is still damp.

b Paint the mauve area right across in a weak wash. Then immediately paint in the nearer trees with thicker paint on top.

c These tree reflections are again painted wet-into-wet.

d The trees here are put in with a fairly dry brush, while the foreground shadows on the snow are stroked in very quickly and lightly.

a

Brush techniques

Now that you have seen how to use the hake brush to create washes for the sky, let's look at other ways in which this brush can be used effectively in the rest of the landscape. Apart from the hake, the other brushes that I normally use – the 25 mm (1 in) flat brush and the rigger – are each ideal for certain landscape features.

b

Using a hake

Imagine first that you want to show hills on the horizon. If you're aiming to portray a wet or misty day, you'll need to put in the hills before the sky has quite dried to convey a soft appearance. If on the other hand, you're painting a blue sky with sparkling cumulus clouds, then you must wait until the sky is completely dry, so that the hills will appear clear and sharp to enhance the atmosphere of a sunny day. Impatience will be your greatest enemy here.
Putting in

your horizon too quickly will ruin an otherwise perfectly good sky.

As you move forward in the scene, you may want to put in fields, trees and hedges. Distant fields can be indicated by swift horizontal strokes of the brush, while distant trees can be put in with downward strokes of a corner of the brush. Rough scrub land in the foreground can be produced by fast strokes of the hake combined with flicks of a fingernail. Try using your knuckles too, in a wet wash, to produce foreground texture.

c

d

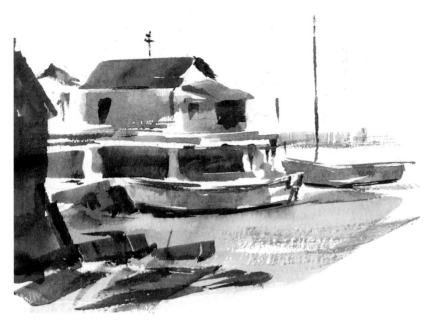

◀ In this illustration of a harbour view, you can see how the 25 mm (1 in) flat brush can produce crisp lines as well as hard-edged objects.

Using a 25 mm (1 in) flat brush

You'll find the 25 mm (1 in) flat brush invaluable in your landscapes – as with the hake, use it with delicacy. The almost knife-like edge will allow you to put in features such as railings, gates, doorways, windows, masts and distant boats. In other words, you can use this brush wherever a sharp edge is required. The 25 mm (1 in) flat comes into its own, too, for indicating distant buildings and sheds.

Take a look at the illustration above, then have a go at using the brush yourself. Soon you'll be producing authentic, yet economical detail in your scene.

Using a rigger

This is another brush that will become indispensable. The amount of pressure is paramount here. The long hair means that, by varying the pressure, you will be able to produce marks ranging from a hair's width to about 6 mm (¼ in). Try holding the brush right at the end of the handle to give you more flexibility of stroke. For a tapering line, move just your fingers rather than the whole hand.

Use the brush for features as diverse as figures, grasses, winter trees and birds. Tree branches in all seasons are best painted with the rigger; try to achieve the uniformly tapering effect so important for authenticity.

▲ To paint this winter tree you will need plenty of practice at holding the rigger at the very end of the handle. Getting enough taper is the aim here.

▲ When painting figures with a rigger, keep them very simple with no features, hands or feet. The most important thing is to make the heads small (an adult figure is about seven heads high).

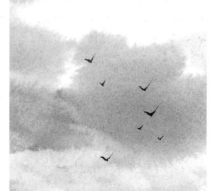

▲ Using a rigger for birds is simplicity itself! But don't overdo it, and vary the sizes to give the impression of distance.

◀ Quick flicks of the rigger give the effect of blades of grass.

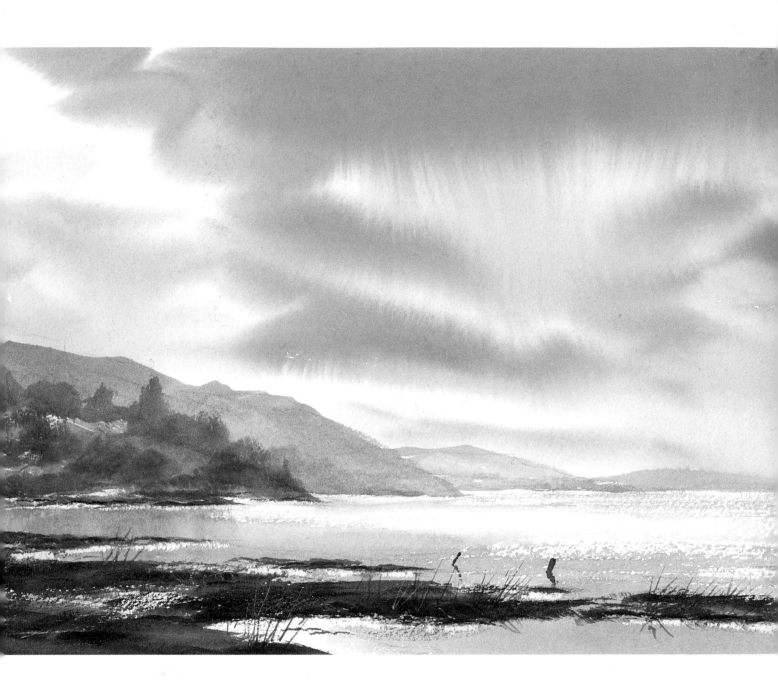

Creating highlights

The following techniques will show you how to introduce highlights and sparkle to your paintings. This is an area where a preliminary tonal sketch (see page 34) will help you to decide where these highlights can be used to the greatest advantage.

Dry brush technique

This technique reproduces effects such as sparkle on water or texture on a road, and works best on Not or rough paper rather than smooth paper. The secret is to put your brush stroke in quickly and lightly on the dry surface of the paper. The paint will be left just on the raised parts of the surface, while the indents remain untouched.

Practise this method of working over and over again on scrap paper until you are pleased with the result. The same technique can be used over a previous wash (once the wash has dried) to create textural effects, perhaps in a foreground. To avoid giving your foregrounds an overly bitty appearance, you can simplify them by standing up and using your whole arm to sweep the brush lightly across the paper.

▲ **Cirrus over an Oregon Lake**
31 x 41 cm (12 x 16 in)
Here, the sparkle was created by painting a wash of Prussian Blue very quickly and lightly over the lake area. The brush just skimmed over the top surface of the paper, leaving the indented areas untouched.

Leaving white paper

The whiteness of the paper is a very important part of painting in watercolour, and there are many occasions when leaving the paper untouched is the best way to produce certain effects. You may wish to portray snow on a mountain or a white house backed by dark trees, for example. You will need to plan these areas beforehand and paint carefully around the desired shapes.

Masking fluid

Perhaps an easier method of leaving your white shape is to paint it first with masking fluid (see page 13), giving the fluid time to dry before starting your painting. Once the watercolour itself has completely dried, the masking fluid can easily be rubbed off with your finger, leaving the required shape untouched.

▶ The area of the castle was painted with masking fluid, using an old brush. Once the fluid had dried, the sky was washed in with abandon. When the sky was quite dry, the masking fluid was rubbed off and the castle completed.

Wiping out

A light, soft streak, perhaps on the surface of water, can be achieved by a sideways, horizontal stroke of a clean, dry hake while the wash is still damp. This is most effective against the darkest part of the water.

For a sharp-edged shape, such as the sail of a yacht, lay two pieces of paper together at an angle on top of the painting and gently rub the surface between them with a damp hog's hair oil-painting brush. I find that a bit of spit on a tissue works well, too – especially on Bockingford paper. Both these methods require patience and delicacy. You'll see examples of yacht sails created by this technique on pages 39 and 45.

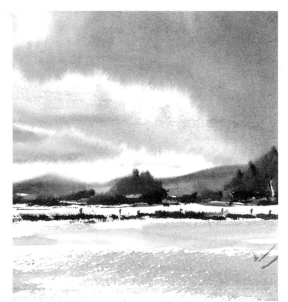

◀ The areas of shadow on the snow were very lightly painted in a mix of Payne's Grey and Crimson Alizarin to match the sky, unifying the two elements. The white paper left showing effectively suggests the brighter patches of snow on the fields.

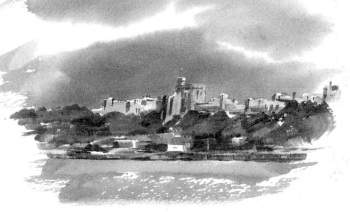

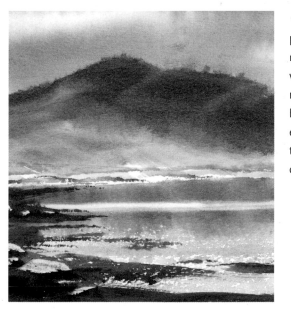

◀ Immediately after painting in the reflected mountain, the hake brush was dried on a rag to make it 'thirsty'. Making a horizontal sweep with the edge of the brush gave the impression of a wind-driven patch of water.

Exploring Colour

As you begin to explore and experiment with colour, it is best to use just a few paints and get to know them really well. Learn how they mix with each other, how they mix with water – in other words, how to make the best possible use of them. Given time and practice, with just a few colours you will soon be producing all the shades you need for your paintings.

An important thing to remember when mixing colours is to keep your paints clean. Often you'll produce the required colour by mixing only two of your originals. Try to work in this way, particularly in the early days, as you will avoid muddiness and ensure freshness. If you have white paint in your selection, never mix it with another colour, as it will only produce a milky opaqueness that will destroy the transparency of watercolour.

Don't be afraid to use watercolour boldly and with courage. Nothing looks worse than a washed-out, weak painting.

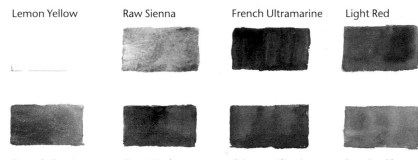

Lemon Yellow Raw Sienna French Ultramarine Light Red

Payne's Grey Burnt Umber Crimson Alizarin Prussian Blue

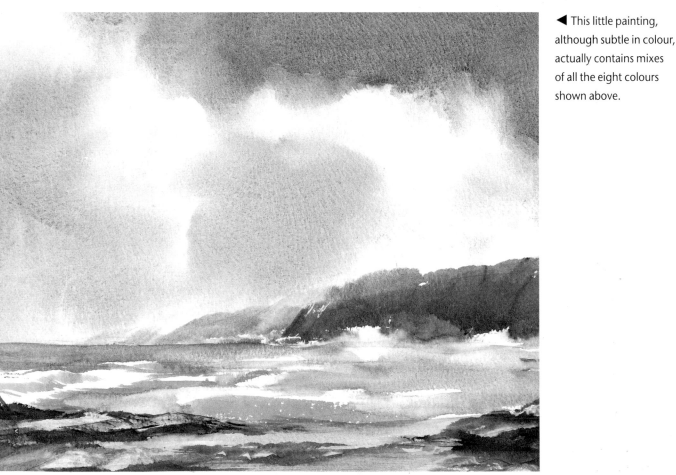

◀ This little painting, although subtle in colour, actually contains mixes of all the eight colours shown above.

Harmonious colours

The illustration on the right shows harmonious colours. These are colours that are closely related, such as orange and red, or green and yellow. Used judiciously, they will always give a sense of peace and pleasure.

Complementary colours

Complementary colours are contrasting colours that are directly opposite each other on the spectrum – for example, red and green, or blue and orange. They can be invaluable in enlivening a painting. A predominantly green landscape, for instance, will come to life with the addition of a touch of light red.

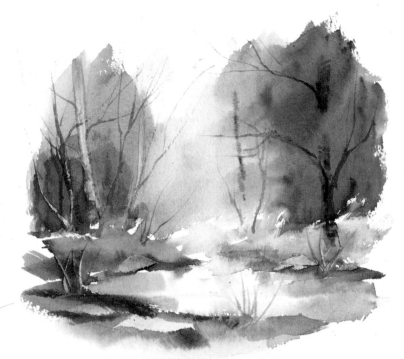

▲ The use of harmonious colours evokes a tranquil atmosphere in this woodland scene.

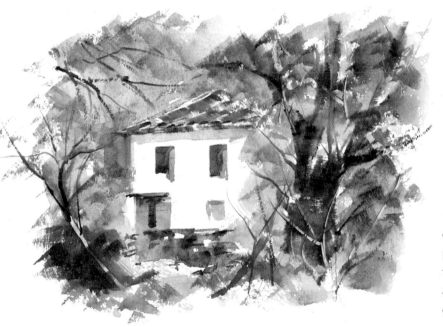

◀ Complementary colours can be used in a painting to draw attention to a particular area, such as the red roof amidst the green foliage.

Warm and cool colours

Warm and cool colours are tremendously useful in a painting. Warm colours will always appear to advance when placed near cool colours. Conversely, cool colours will appear to recede when used near warm colours. You will be able to exploit these qualitites to great effect to convey space and recession in your painting by using warm colours in the foreground of your scene and cool colours for distant objects.

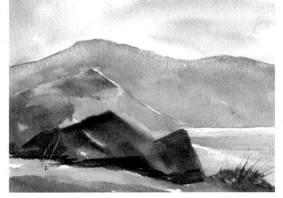

◀ Notice here how the warm rich colours of the foreground rock push back the cool colours of the distant hills.

21

Colours for skies

Let's look now at sky painting in particular. Virtually every sky portrayed in this book is built up from the following colours: Raw Sienna, Payne's Grey, Crimson Alizarin, Lemon Yellow, French Ultramarine, Prussian Blue and Light Red. As I said earlier, you can add to these to suit your taste, but as you need to concentrate on the varied water content and the timing of each part of the sky, you can see the advantage of limiting your colours.

Here are some basic skies with swatches showing the colours used to paint them.

Clear sky

The clear blue sky in the first illustration must be graduated to look effective. Applied over a very weak wash of Raw Sienna, a rich French Ultramarine gradually becomes paler from the top to the bottom of the sky, until the colour fades to a light cream at the horizon.

Cumulus clouds

Once again, a very pale Raw Sienna forms the basic wash across the sky area. French Ultramarine, painted around the cloud shape, forms the blue of the sky, leaving the cream colour to suggest the cloud itself. The shadowed base of the cloud is a mix of Payne's Grey and a little Crimson Alizarin.

Cloudy sky

After the usual very pale Raw Sienna wash, the clouds are painted in quickly with a mix of Payne's Grey and Crimson Alizarin – the same mix as used for the base of the cloud in the cumulus sky.

Sunset

After the initial wash of Raw Sienna, a brush full of French Ultramarine creates a darker tone across the top of the sky. The touches of pink and yellow typical of a sunset are added with Crimson Alizarin and Lemon Yellow, put on in varying strengths and allowed to blend. The clouds are a stronger mixture of Payne's Grey and Crimson Alizarin.

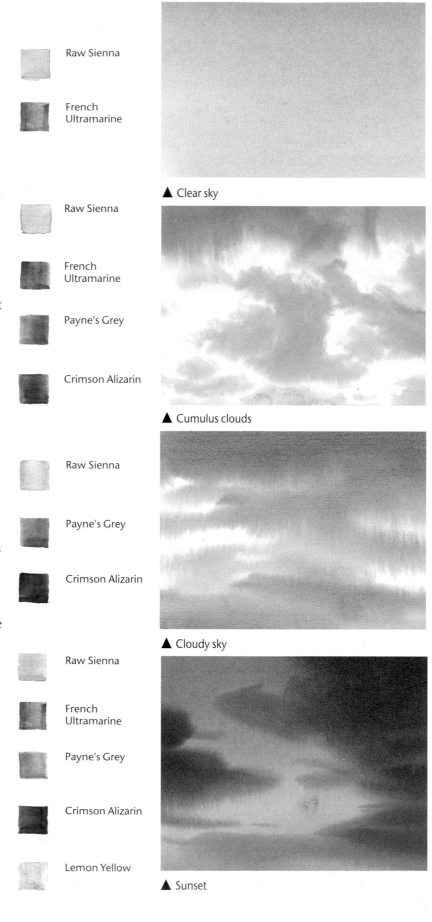

Raw Sienna

French Ultramarine

▲ Clear sky

Raw Sienna

French Ultramarine

Payne's Grey

Crimson Alizarin

▲ Cumulus clouds

Raw Sienna

Payne's Grey

Crimson Alizarin

▲ Cloudy sky

Raw Sienna

French Ultramarine

Payne's Grey

Crimson Alizarin

Lemon Yellow

▲ Sunset

Landscape colours

You can't avoid learning how to mix a good range of greens for the landscapes beneath your skies. The whole range can be obtained by using blue, yellow, grey and Raw Sienna.

On this page, I've demonstrated how to obtain the effect of distance by using cool blue-greens in the background, and building up to rich, warm greens in the foreground. The dark, rich greens are mixed with much less water. Try mixing the range of greens on some scraps of paper first, then move on to copying the illustrations.

Turning to earth shades, there are greens here too, but now you need to move towards warmer foreground colours mixed from the range shown below. Again, practise copying these on to spare paper to get the feeling of the colours. You'll soon find that different colours will vary the atmosphere in your paintings.

▼ This vignette uses the whole spectrum of greens.

▼ There is still plenty of green in this landscape, but with added touches of Burnt Umber and Light Red.

▲ To obtain this range of greens, you'll need to start at the back with French Ultramarine and the merest touch of yellow, then gradually add more yellow as you move forwards. Once you have applied the brightest green, begin to add Payne's Grey until you reach the darkest green in the foreground, which contains much less water.

► Useful earth colours can be mixed from (left to right) Raw Sienna, Light Red, Burnt Umber and French Ultramarine.

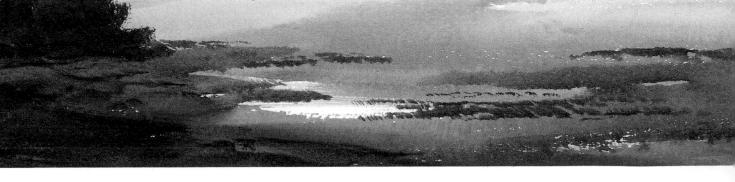

Simple Skies

The time has come for you to have a go at some complete skies yourself. Some of the different sky types are set out on these four pages for you to copy. Arm yourself with lots of paper, perhaps paper that you've already used on one side. Remember that you'll get the best results if you work with your board at an angle of about 45 degrees.

If your skies don't work first time, don't be discouraged – just enjoy experimenting with the paint and water. It may take several attempts before you get the right water content which will make your skies believable. A few initial disasters are all part of the learning process!

Clear sky

1 Using a hake, paint an extremely weak wash of Raw Sienna over the whole sky area. It should appear as a very pale cream colour.

2 Now mix up a rich wash of French Ultramarine and immediately, while the first wash is still wet, put in a band of the blue right across the top of the page.

3 Continue putting the Ultramarine in, using your whole arm to move the brush backwards and forwards, and gradually taking the pressure off the brush as you work down the sky. Now stand back and watch. If you've got it right, gravity will take out any streaks and you'll be left with a lovely, clear, graduated sky after a couple of minutes. If you haven't achieved this, try again!

◀ 1

▼ 3

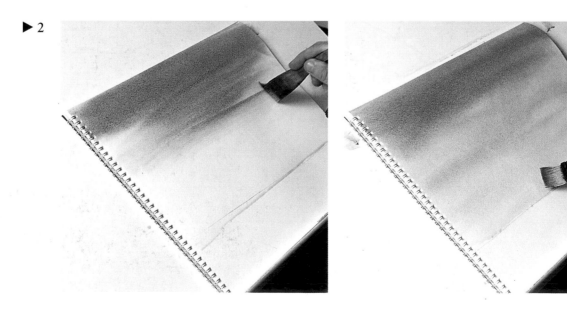

▶ 2

Cirrus sky

1 As in the previous example, put on a very pale wash of Raw Sienna. With rich French Ultramarine, immediately use your hake to begin making streaks across the sky in a curve.

2 Continue adding Ultramarine – it is really important to use your whole arm to get a smooth sweep of colour. Note that the blue is creating negative shapes, and the original wash showing through is what forms the clouds. As you move down the sky, the cream streaks left by the blue should be narrower and closer together, to give perspective.

3 Wait and watch for a couple of minutes and you'll see the clouds soften and become authentic-looking cirrus. Again, if there's a problem, it's almost certain to be that the blue is going in too wet, or that you've waited too long before putting it in.

▲ 1

◄ 2

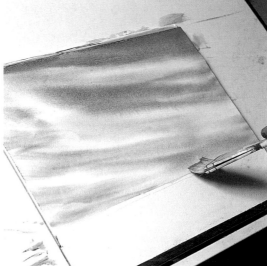

◄ 3

► A quick vignette of a cirrus sky.

Rain clouds

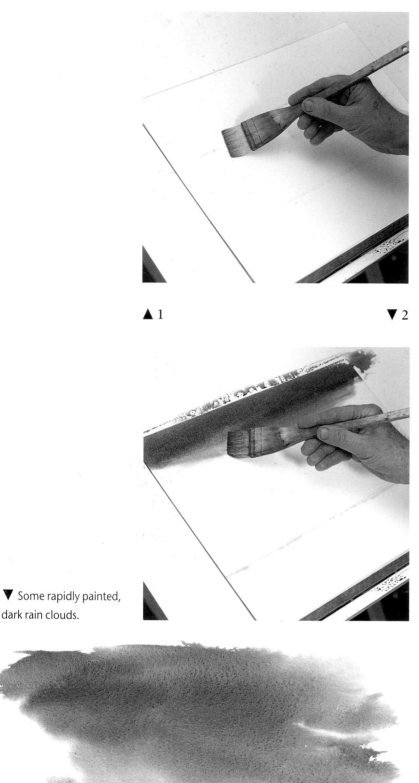

▲ 1

▼ 2

1 As before, put on your very pale Raw Sienna wash – this time it needs to be even wetter than before.

2 Mix up some good, rich Payne's Grey, with just enough Crimson Alizarin to warm it up (too much will make it pink). Load your hake with the mix and put in one large cloud across the top of the page. It is vital that your grey goes on darker than you think it should, as it will fade back considerably as it dries.

3 Move on down the page, producing smaller clouds, but allowing some of the original cream-coloured wash to show. Again, use a whole arm motion to do this. As you reach the horizon, remember to make the clouds narrower and closer together, so that they appear further away.

Now you must wait again for a couple of minutes while you watch your clouds move and soften. If you've got it right, you'll want to put up an umbrella!

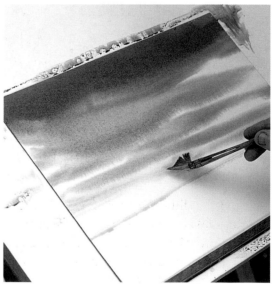

▲ 3

▼ Some rapidly painted, dark rain clouds.

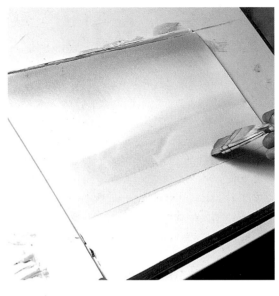
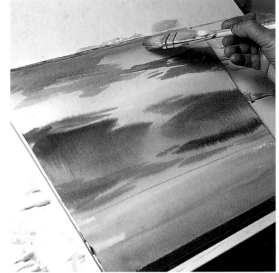

▲ 1 ▼ 2 ▲ 3

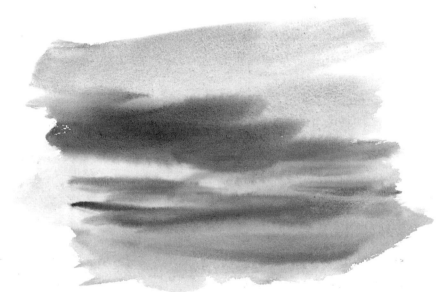

Evening sky

1 This sky is a little more complicated, but exciting and great fun to try. After the usual initial wash of Raw Sienna, put in a touch of blue at the top of the sky and graduate it to about a third of the way down.

2 Mix some Lemon Yellow and a little Crimson Alizarin and paint this across the bottom of the still wet Raw Sienna wash.

3 While your evening sky is softening, mix some very strong Payne's Grey and Crimson

Alizarin (a little more Alizarin than for the rain clouds). Now paint this in to form roughly sausage-shaped evening clouds, again remembering to make them smaller and closer together as you reach the horizon. As always, timing is critical and you have to work even faster than usual to make this sky look authentic.

▲ Practise doing quick little sky studies like this on scrap paper.

Composition and Design

Just as you wouldn't dream of building a house without an architect's plan, neither should you begin a painting without thinking it through first. The only materials you need at this stage are a sketch pad and a soft pencil to try out some rough ideas for various compositions. I can't emphasize enough how important this pre-planning is – without it your painting simply won't progress in quality.

You can always tell when looking at a finished painting whether or not the artist is proficient in composition and design. No matter how beautifully applied the washes are or how well the colours are mixed, if a piece of work is poorly composed, it will never become a notable and satisfying painting. It will appear disjointed and lacking in harmony, and it won't invite the viewer into the scene. In other words, it simply won't 'gel'. It's very difficult to persuade my students that this pre-planning is worthwhile, but if you really want your paintings to improve – it is!

◄ Placing the horizon right across the centre is inclined to chop the picture into two halves, which is visually unsatisfying.

Placing the horizon

Perhaps the worst mistake you could make, especially when making sky paintings, is to place the horizon exactly in the centre of the paper. This immediately has the effect of chopping the painting in two. In most of the paintings throughout this book, the horizon has been lowered to give more prominence to the sky itself. Obviously, if you want to give more dominance to the foreground, you would move the horizon towards the top of the painting.

▼ Here the horizon is high with very little sky, just enough to show the mist on top of the hill. This gives more importance to the landscape features in the foreground.

▼ It is more usual to compose a sky painting with a low horizon. The area of land below the horizon simply provides a focal point and contrasting texture.

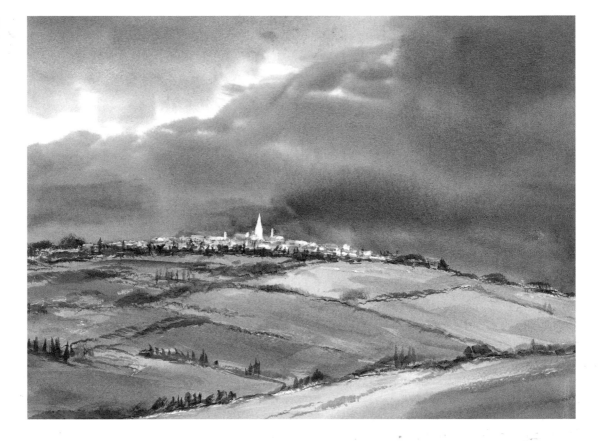

▶ **A Hilltop Town in Tuscany**

31 x 41 cm (12 x 16 in)
The focal point of this painting is the distant town with its sunlit church, deliberately contrasted against the dark sky behind.

The focal point

Another very important aspect to remember is that every picture needs a main point of interest, or focal point – an area or an object to which the eye is immediately drawn. This can be achieved in different ways. For example, the focal point could be the only man-made object in the painting, such as a boat or a house, no matter how small. Or it could be an animal or person. It might be the area of greatest contrast, such as the only white object against a dark background, or even the largest tree. As you look at the various illustrations throughout the book, you'll see what I mean.

There is a definite rule about positioning this main object of interest. Ideally, it should be at a different distance from each edge of the paper, and certainly never in the centre.

▼ Here the eye is led into the picture by the track, taking the viewer to the barn – the main object of interest.

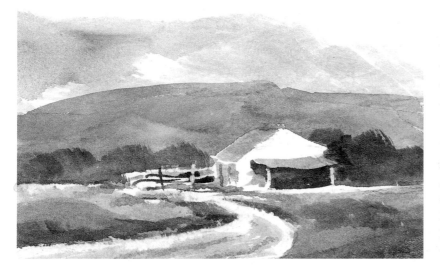

Leading the eye

The third point about composition is that you should make it as easy as possible for the viewer's eye to enter into your painting, and then to move around it to the main object of interest. Pathways, rivers, curving coastlines or shadows can all be used to achieve this. You might have noticed from the paintings of the great masters how adept they were in this aspect of composition. The Dutch painter Rembrandt (1606-69), for example, was highly skilled at leading the viewer's eye wherever he wanted to around his paintings.

Design principles

Apart from being aware of the importance of good composition, you should also try to follow some basic rules of design, as these will greatly enhance your work. These rules are straightforward and are largely a matter of common sense. The seven main principles are listed below:

Unity, Contrast, Dominance, Variation, Balance, Harmony, Gradation

You may not always need to include all seven principles in a single painting, but the more of them you adhere to, the more satisfactory will be the finished result. Take a look at each one separately in the examples that follow, thinking particularly about the ways in which they can be applied to skies.

Unity

A unified painting is one that is a harmonious whole, rather than a disjointed collection of objects. One way of achieving unity, which works particularly well in a sky painting, is to echo a tree or barn with a cloud shape . This also provides you with another aspect of unity, as the tree or barn unifies earth and sky, acting as a link between the two. A further unifying factor is to make some of the colours echo one another throughout the picture. In a sky painting, the most obvious way of doing this is to show the sky colour reflected in water or mud below.

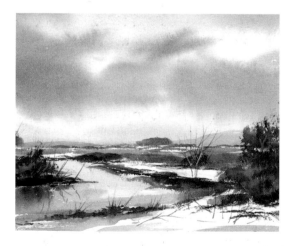

▲ The landscape and sky above are unified by showing the colours of the sky reflected in the water, while the trees link the two areas of the painting.

Contrast

Contrast, correctly applied in a painting, is a sure way to create excitement and interest. It is one of the principles that you will find easy to apply to every scene you create. There are many ways of providing contrast. For example, you can contrast hard against soft with, perhaps, a church steeple silhouetted against soft cloud. For a contrast of tone, you might use a sunlit building against a threatening sky.

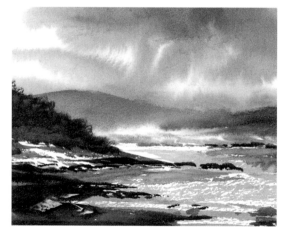

◀ The contrast is achieved here by placing the darkest parts of the picture – the rocks – immediately adjacent to the light areas. The dark clouds, too, contrast with the lighter areas of the sky, although not so strongly.

Dominance

This is largely a matter of common sense. When you are painting a sky, you should make one cloud larger or darker – in other words, more dominant – than the rest. Also, avoid dividing the sky equally between cloud and patches of blue. Give one area more importance than the other.

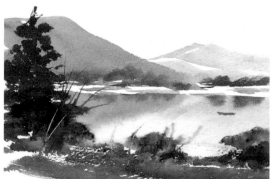

◀ The rich, dark green colour of the tree in the foreground ensures that this is the dominant part of the painting.

Variation

Variation is, as it sounds, a matter of avoiding monotony in repeated objects by changing their shape, size and colour. In a sky painting, this might be a matter of varying the cloud shapes and ensuring that the spaces between them are always different.

► Although these trees are positioned in a row and are of similar size, the colours are constantly changed to bring entertainment to the eye.

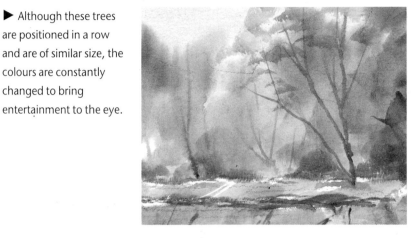

Harmony

Shapes and colours can both provide the harmonious elements needed in any painting. Think of similar circular and oval shapes, or a range of mauve and blue colours. A boulder in the foreground could perhaps be echoed by a cloud shape in the sky, while foreground shadows could be repeated in shape and colour in the sky above.

▲ The harmonizing effect in this peaceful little scene is brought about by the use of related colours. There are no strongly opposing colours.

Balance

Although there are different ways of balancing a painting, the most obvious and easiest example in a skyscape is to create a dark tone in the landscape, such as in a tree or building, to balance a dark cloud. The objects that balance each other should be different in size and be positioned obliquely.

Gradation

This principle is particularly important when you are portraying a large area of one colour, such as a cloudless blue sky. To avoid monotony, graduate the colour from a deep rich blue at the top to a cool cream on the horizon. Even in a completely overcast sky, take care to change the colour gradually, perhaps from palest grey to a deep, rich, thundercloud purple.

▲ Informal balance is achieved by using the darker area of foreground rocks to balance the contrasted hut on the left of the scene.

► You'll notice here how the colours of the dominant cloud and the hillside on the right have been gradually changed to avoid boredom.

Perspective

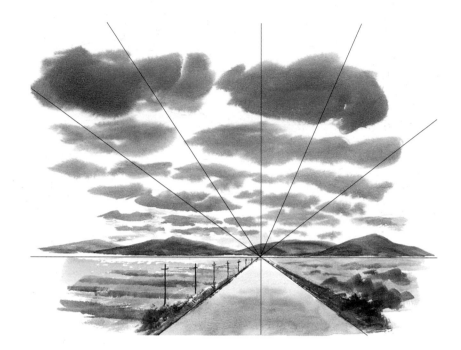

Perspective is a word that strikes fear into the hearts of many an aspiring artist and yet, once tackled, it quickly becomes second nature. Your buildings will sit firmly on the ground, while trees and figures will recede into the distance as you narrow your roads.

So let me begin by explaining as simply as possible the basic facts about perspective. There are actually two kinds of perspective: linear and aerial. Linear perspective applies to skyscapes just as much as to landscapes, so let's look at this first.

Linear perspective

Put in its simplest form, the further away things are, the smaller they become. A good example of this is the effect you get when you look along a line of telegraph poles. Everyone can see and understand this, but then they often seem to forget it on picking up their brushes and paints.

I find this particularly apparent when people are painting skies – many of my students paint all the clouds the same size, whether they are directly above them or right on the horizon. The resulting sky appears flat and uninteresting. All you need to do to avoid this is to apply the telegraph pole principle. You'll see immediately that the cloud above you must appear many times bigger than the cloud on the distant horizon.

Having mentioned the horizon, I must also add how vital this is to the whole question of perspective. As you look ahead of you, the horizon is at your eye level, and is where the lines of perspective meet at a 'vanishing point'. If you were looking along a railway track, this is where the two parallel lines of the rails would appear to meet.

Aerial perspective

Turning to aerial perspective, this is based on the basic principle of light tones appearing to recede into the distance, while darker tones seem to come forward. While aerial perspective will never be as apparent in skies

▲ This diagrammatic illustration shows how linear perspective applies to clouds just as much as to roads and telegraph poles.

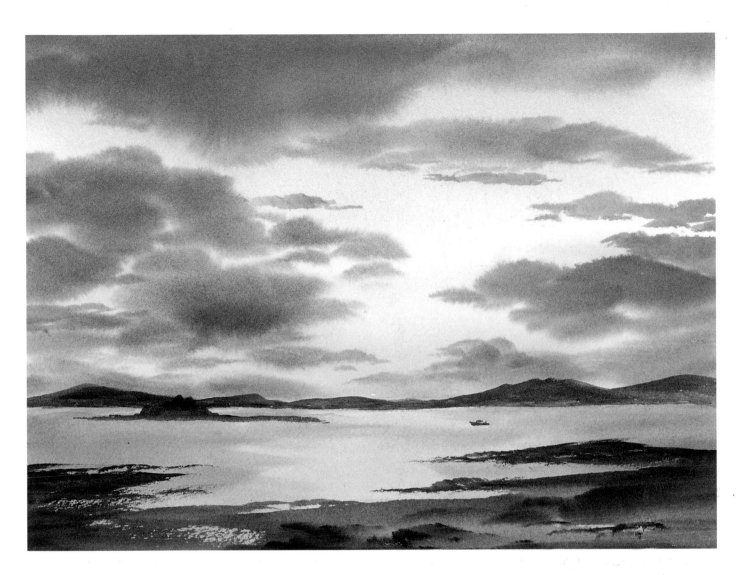

as linear perspective, it could perhaps be applied by giving large, nearby clouds stronger tones and more contrast than those on the horizon.

Another important fact to remember is that objects appear to contain more blue the further away they are – in other words, they are cooler in colour. Nearby objects will always be richer and warmer.

When painting, it is always best to begin in the distance, gradually moving forward in planes to the foreground. What you should do is to start off in a whisper with pale, bluish colours, possibly applied wet-into-wet so that they are soft and out-of-focus. Then raise your voice with stronger, richer colours until you reach the foreground.

Greens in the countryside are a useful example. If you paint a distant tree or even a meadow in too rich a green, you will immediately bring it forward. You need to reserve these rich greens for the foreground trees and vegetation.

▲ **Evening on the Lake**
31 x 41 cm (12 x 16 in)
Notice here the size of the clouds on the horizon compared with those at the top of the sky.

◄ **Off the Norwegian Coast**
20 x 20 cm (8 x 8 in)
The cool colours and light tones of the distant mountains are made to recede by using strong, rich colours and tones for the foreground rocks.

Working on Location

At first, it takes nerve to move outside to paint in the open air. You have to overcome the embarrassment of being watched and, to your own mind, being judged by the onlookers. However, working outside really is an essential part of your training as an artist, and your confidence will increase rapidly the more you try it. Apart from that, you'll soon learn that there is nothing like the excitement of setting down on paper the scene directly in front of you.

There are two options here. The first is simply to take out a small sketch pad and soft pencils and sketch your chosen scene. You can then take the sketch back to the studio to be translated into a painting later. As a beginner you may find that this is the less obtrusive option, as it doesn't attract curious onlookers. The second option is to set up your easel and watercolour materials and produce your whole picture on site.

▲ Two simple pencil sketches made with a 4B pencil in a spiral-bound cartridge pad. They can be used as references for paintings later on.

◄ Ron Ranson going out to paint on location with his folding metal easel and other essential equipment.

Making reference sketches

The most important point to remember when sketching is to use a whole range of tones, from white paper to solid black. Merely drawing outlines, or 'wire' as I call it, simply doesn't work, as this won't provide enough information to produce a painting back in the studio. You'll see what I mean from the sketches on this page.

Perhaps the best advice I can give you is to use only soft pencils – 2B to 6B. The most common pencils around, which are HB, won't produce a wide enough range of tones and are best kept just for writing.

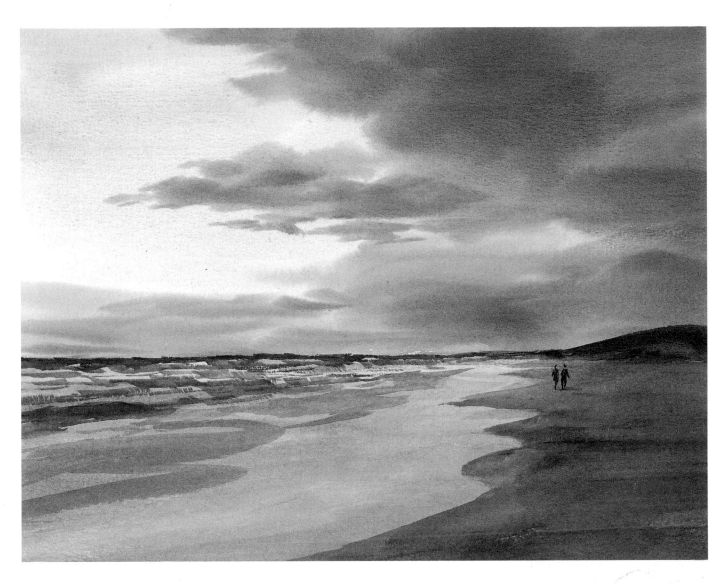

Painting outdoors

While we have to accept that there are problems when painting outdoors, most of these can be overcome with a little foresight and planning. One important point is to keep your equipment simple. Don't weight yourself down with masses of materials. Instead, make a check-list of absolute necessities and stick to it. This will also ensure that you take everything with you. There is nothing worse than finding the perfect spot to paint in, then discovering that you've no water, or have left your brushes or paints at home.

Be prepared for windy conditions. Keep some bull-dog clips with you to secure your paper to your board. With regard to the easel, the lightest probably isn't the best,

especially in wind. One way of holding your easel down is to tie some cord to it where the legs meet, and make a slip knot loop at the other end. All you need then is a weight, such as a large stone or log, to put into the loop to steady the easel. Having said that though, you can often find shelter from the wind behind a wall or building.

Direct sun can be a problem, too. Try to avoid the sun shining straight on to your paper. If you paint in such bright light, you'll probably be disappointed with the washed-out appearance of your painting when you get it home.

A time to avoid, therefore, is midday, when the sun is immediately overhead. Before 10 a.m. and after 4 p.m., you'll find the light, as well as the shadows, more interesting.

▲ **An Evening Stroll**
29 x 38 cm (11½ x 15 in)
This simple scene was painted one evening on a beach in South Africa. The darkening sky is streaked with soft coral pink from the setting sun.

While on the subject of shadows, make sure you don't paint them in at different times as, over a two-hour period or so, their direction will change as the position of the sunlight alters. Wait until you've finished the rest of the painting and then put them in all at one time. In this respect, perhaps the easiest of conditions to paint in is bright but overcast light, which will remain constant for many hours.

One type of weather condition you can do nothing about is rain, which can rapidly ruin a painting. At the first spot, turn your paper over and wait until the shower has passed. You can't fight rain with watercolour.

When you are looking for a good location to paint, take care to avoid trespassing. Always get permission before going on to private land, and be careful about closing gates and carrying your rubbish away with you. Artists are often regarded as rather special, so have a care and don't abuse the privilege.

When working in a town location, try to be as unobtrusive as possible, preferably not setting up your easel in the middle of a crowded pavement. However discreet you are, though, you'll inevitably be seen as a free show and find yourself the centre of attention. It is in situations like this that a sketchbook and camera are of great benefit.

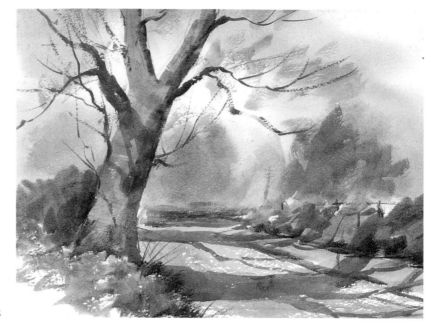

▲ Shadows are most interesting when the sun is low in the sky. The shadows across the path in this painting help to define the surface.

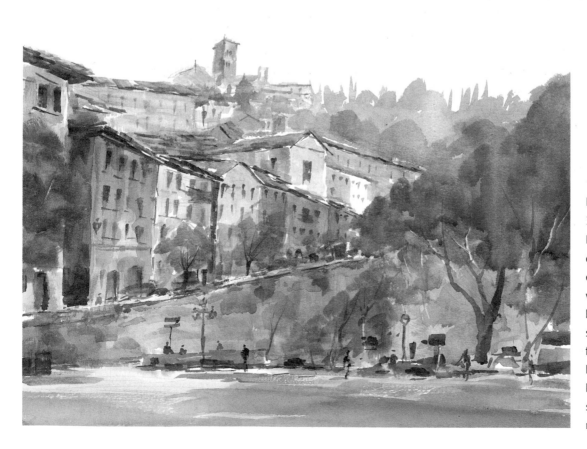

◄ Tuscan Hilltop Town
31 x 38 cm (12 x 15 in)
I painted this scene quite quickly, sitting on a wall out of everyone's way, with a constant stream of buses starting and stopping in the immediate foreground. With this high horizon, the sky has a less important role, but still harmonizes with the rest of the painting.

▲ Here I'm enjoying myself painting on a beach in Oregon in the USA. The view in front of me when the photograph was taken is shown in the picture on the right.

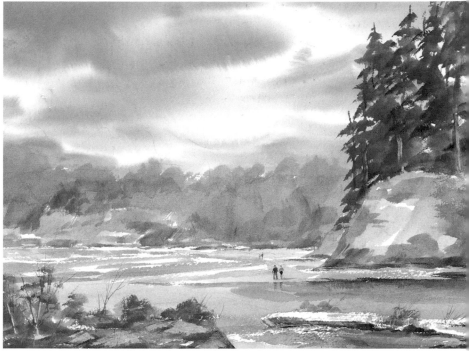

▶ **Short Sands Beach, Oregon**
28 x 40 cm (11 x 15½ in)
The pale clouds are echoed by the highlights on the sea. The figures add a sense of scale.

Painting on holiday

There are many advantages in working with a group of like-minded people. For instance, it overcomes the anxiety of working alone, either in the countryside or in towns. Possibly one of the most enjoyable ways of joining a group is to go on an organized painting holiday, either at home or abroad. These are usually tutored and you'll find that you will make good progress, as well as good friends. Non-painting partners are usually welcomed.

This doesn't mean, however, that you can't paint on your own trips away. Paintings and sketches will give you a far livelier record of your adventures than any number of holiday snaps.

Taking reference photographs

Your cameras need to be light and compact if you wish to remain as unobtrusive as possible. It's important that you learn to compose your photographs properly, using the same rules of composition as you would in a painting. It's a strange phenomenon, but artists who spend time composing their paintings will forget entirely about design when looking through the viewfinder of a camera.

As a sky painter, it's a good idea to build up a large reference collection of various cloud formations to choose from when you are working on paintings in the future. You'll often get sky conditions which will disappear in seconds, but which can be captured on film and added to your reference library.

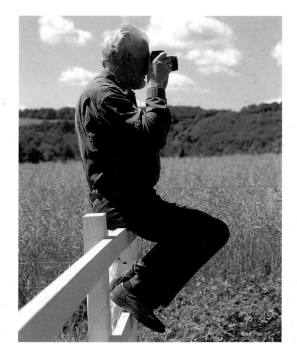

◀ Sitting on a fence taking photographs of an exciting sky.

37

Working in the Studio

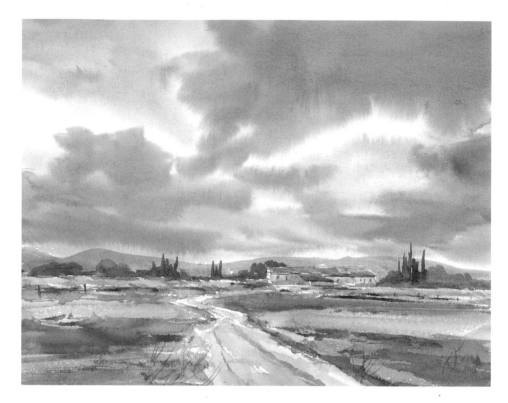

As I said in the previous chapter, there's no substitute for working outdoors. However, working in the studio can bring its own rewards. You have time to concentrate and there are fewer distractions from sun, wind and rain. It's also an ideal time to experiment. Don't feel that you always have to produce a finished painting. Think of the experience rather than the product, so that you are not held back by having set yourself a goal you must reach.

If it is at all possible, try to create a small space for yourself. You don't need a huge studio, but a 'painting space' in which you can leave your materials set out is invaluable.

Painting from references

Think about how you can make the best use of the reference material that you've gathered on location, both photographs and sketches.

Not that you should ever copy this material too literally; its purpose is to provide you with information and inspiration. Even though you may feel that you can produce a perfectly good sky out of your head, you will ensure authenticity by basing it roughly on a photograph. However, the finished painting will be your own individual interpretation of the scene, in which your memory of the atmosphere of the place will be aided by your references.

When you're working from reference material in the studio, speed is essential to maintain freshness but most of all to avoid overworking. The secret is to let a watercolour sky 'do its own thing' on a sloping surface. Don't push it around and play with it.

Try standing up for your sky painting, so that you have room for whole arm movements. This, combined with the use of the hake brush, will help you to produce fresh

▲ **Memories of Tuscany**
29 x 37 cm (11½ x 14½ in)
Having enjoyed running a workshop in Tuscany, I extended my enjoyment by painting this rural scene, with its important and busy sky, at home from memory.

yet strong skies, even though you are not working directly from the subject. Remember, too, that sky colour will always fade back when it dries, so give yourself a fright and use rich, strong colour. As one of my favourite artists, Ed Whitney, used to say, 'If it's right when it's wet, it's wrong when it's dry'.

Working from sketches

If you are working from sketches made on site, feel free to improve upon nature if necessary by moving objects around or by changing the heights of hills or mountains, for example. Look back to pages 28 to 31 to remind yourself of the principles of good composition and design.

The tonal sketches you made on location will be invaluable to remind you of the lights and darks in the original scene. Once again, you can enhance tones or enrich colours if you feel that this would improve the impact of the painting.

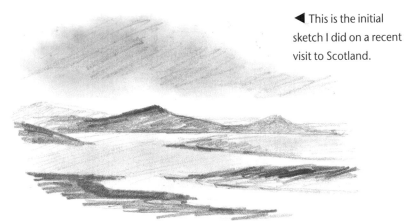

◄ This is the initial sketch I did on a recent visit to Scotland.

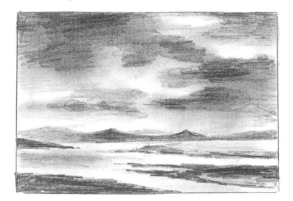

◄ Here, I've altered the lighting on the right of the middle distance to dramatize the sunlit shore. I've also darkened the tone of the right-hand foreground to balance the rich, dark cloud at top left.

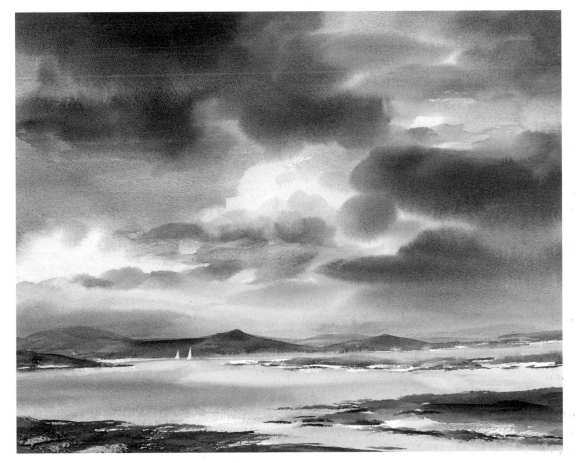

◄ Sunlight and Shadow
28 x 35 cm (11 x 14 in)
In the finished painting, I wanted to create as much drama as possible by enriching the colour and deepening the tones. This type of lighting effect may only last for half a minute before it changes, hence the need for the sketches above.

► Photograph of a scene taken in California.

▲ Tonal sketch showing a change from a clear sky to cirrus clouds. Also, the horizon has been lowered.

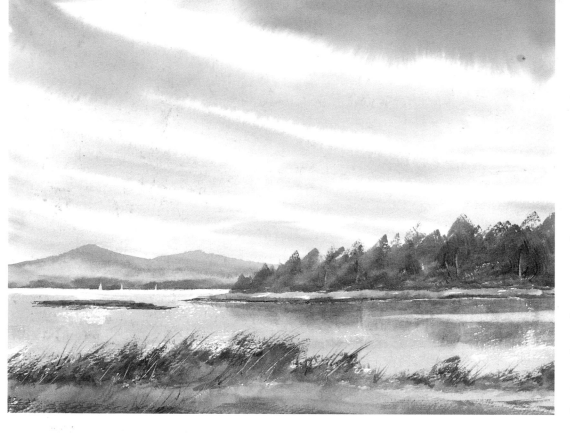

◄ **Distant Sails, California**
31 x 40 cm (12 x 15½ in)
You can see in this finished painting how the sky has been made much more important, while the foreground has been minimized and simplified. The grasses have been used to balance the trees in the middle distance on the right.

Working from photographs

You may find, as you sort through your photographic references, that you have some beautiful landscapes with skies that look white and uninteresting. Don't necessarily blame yourself – it's just that the camera has got confused! An automatic camera will have worked out the exposure of the landscape, meaning that the much lighter sky will be overexposed and will therefore look bleached out. Conversely, if you are concentrating specifically on photographing the sky, the landscape beneath it will look too dark – underexposed, in fact.

Another problem to overcome when taking photographic references is that the beautiful scene in front of you may have a flat, overcast sky above it. On a different occasion, there might be a wonderful sky with nothing of much interest underneath it. The answer here is quite simple – mix and match.

You'll find on the opposite page an illustration of how an interesting sky from a different source can vastly improve a landscape painting. Do make sure, though,

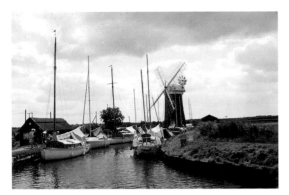

◀ I took this photograph on the Norfolk Broads. The sky is overcast and rather dull.

▶ This is a photograph of an interesting cloud formation, taken at home.

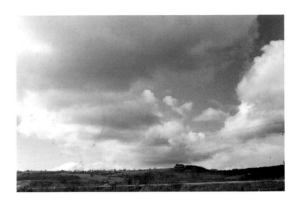

that your sky and landscape do actually match. This applies particularly to a scene with a lake or estuary in it – you will need to change the colour in the water to reflect the colour of the sky that you've decided to use.

Remember, when working from reference material, that you're not setting out to copy skies exactly from your photographs; in fact, it would be impossible to do so. Take from any photograph just the elements of the sky that you feel would be suitable for your painting – it may well be that you decide to use only a section, such as an interesting cloud formation.

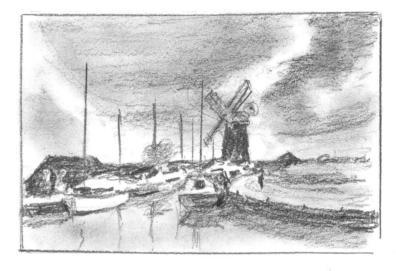

▲ The tonal sketch shows how I have incorporated the two photographs into a single composition, using the curve of the cloud formation to echo the sweep of the river.

◀ **Horsey Mere**
29 x 38 cm (11½ x 15 in)
You'll see here how I have simplified the rather complex boats, making a lot of use of the white paper. Notice how the eye is taken round the curve of the river to the main object of interest – the windmill. The colour of the sky has been heightened to add more impact to the scene.

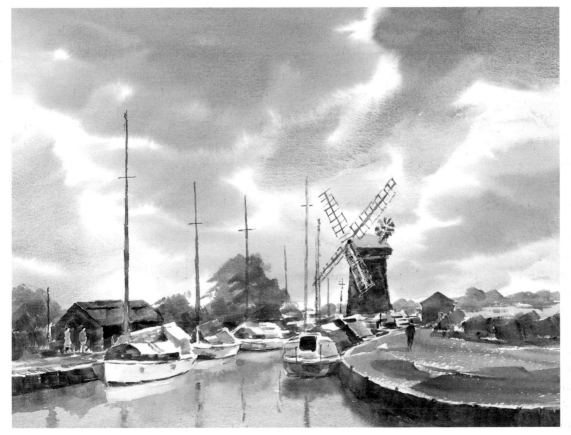

Creating Atmosphere

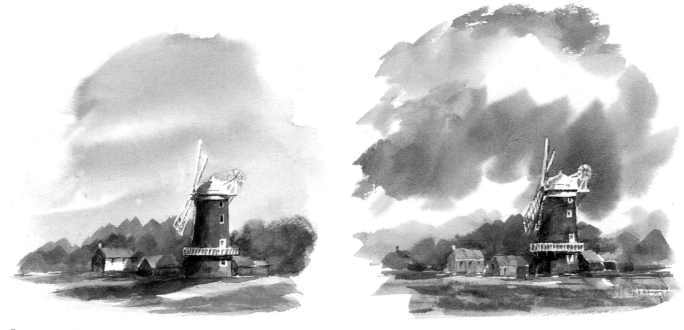

▲ In these two paintings you can see the difference in atmosphere created by the different sky conditions behind the windmill.

At the beginning of the book, I mentioned briefly the impact that skies have on the appearance and atmosphere of the landscape below. In this chapter, you'll find examples of this, including rather more extreme atmospheric effects such as mist, snow, light shining through clouds, reflected sunlight and shadows. All these need different techniques if you are to depict them with authenticity. It's an exciting, challenging area, which will test your skill and require plenty of practice. However, it will also bring you a lot of pleasure.

Mist

There is no medium that lends itself better to the portrayal of mist than watercolour. Consider first what mist actually is. The easiest way to explain it is as a cloud on the ground, consisting of fine particles of water which form a series of 'veils'. If you study J.M.W. Turner's (1775-1851) portrayal of misty scenes, you'll notice that they are always full of subtle and restrained colour, never just grey. Think of a landscape in the early morning, when the sun is just beginning to break through the mist – the whole scene would be bathed in various golden tones.

In any misty scene, the tones are flattened and you'll be painting silhouettes with very little detail. However, you'll need a strong foreground interest to emphasize the effect of the mist. Not everything should be woolly and soft.

Perhaps the best way to begin this type of scene is to wet the whole surface of the paper and then work from the distance to the foreground, gradually increasing the strength

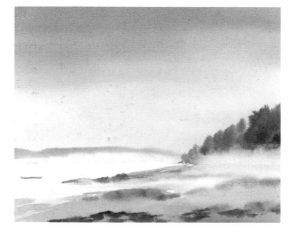

◀ **Morning Mist on the Coast of Maine**
25 x 33 cm (10 x 13 in)
This scene shows the rolling ground mist that is so prevalent on this coast. After putting in the tops of the trees in relatively strong colour, the bottom part of the trees was softened by using clear water.

of your paint for each plane. You'll find that when you reach the foreground, the paper will be almost dry, so that your image will be crisper and stronger – just as it should be.

Shadows

When scattered clouds pass over a landscape, particularly over hills, they produce attractive patterns of light and shade, which can be helpful in indicating the profile of the scenery below. Shadows also add excitement and variety to a scene.

Snow

Snow scenes are possibly the most attractive to any artist and are a joy to paint. You'll need to handle them with discretion, though. Do remember that snow on the ground is never universally white because,

although the effects are more subtle than with water, it does to a certain extent reflect the sky above. Keep this in mind and you'll find that your snow scenes will improve dramatically.

Shadows are even more important in snowy landscapes than usual, as they show the profile of the ground in the absence of other features. They also present a wonderful opportunity to use subtle mixes of blues and mauves.

Creating falling snow requires a little experimentation, but can be great fun to do. Take an old toothbrush and load it with some opaque white gouache. Then rub a pencil or the handle of a paint brush towards you across the top of the toothbrush. The paint will spatter on to the paper and can look very pleasing. Don't over do the spattering though – as with so many other aspects of creating atmosphere, subtlety is all.

▼ **Winter Dawn**
28 x 38 cm (11 x 15 in)
This painting shows how you can give the impression of falling snow by spatttering white gouache from a toothbrush.

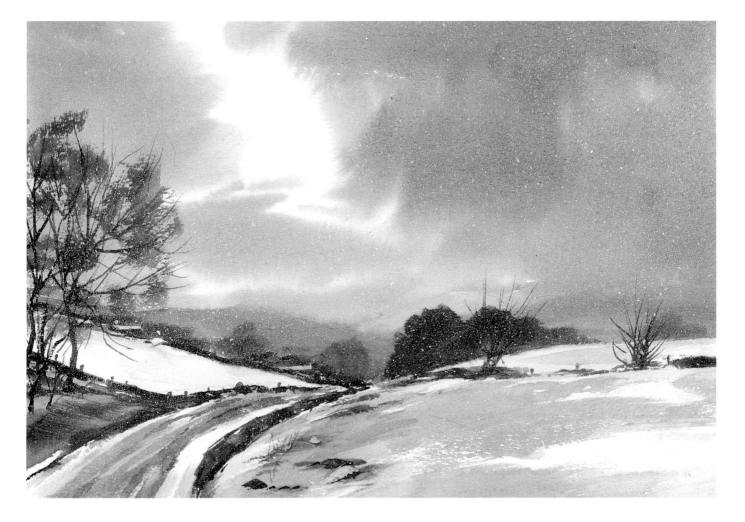

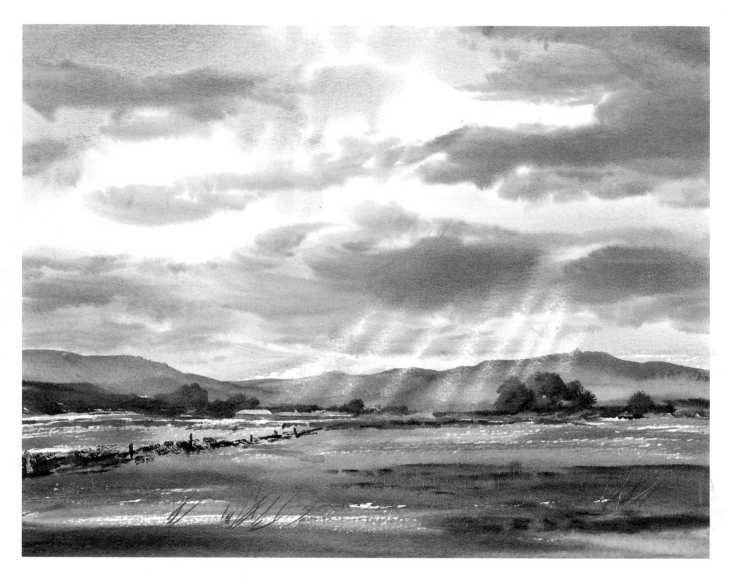

Sun through clouds

A fascinating and popular effect to attempt is depicting the rays of the sun coming from behind clouds. Here, it isn't the application of paint that's important, but the removal of it from a completely dry painting. To achieve this, use an eraser to rub away lines of paint from the area beneath the clouds, remembering that the rays are not parallel, but radiate out from the hidden sun.

Experiment with different erasers for different effects. Softest of all is a putty eraser, then an ordinary pencil eraser. The hardest is an ink eraser. The paper on which you are working makes a difference, too. Bockingford watercolour paper, in particular, is very responsive to this technique.

▲ **Silver Rays**
29 x 38 cm (11½ x 15 in)
Here, enough paint was removed with a soft eraser to depict the sun's rays shining on to the ground. Notice how the rays radiate outwards from the cloud-covered sun.

Don't be too firm with watercolour. Give it freedom to express itself.

Sparkle on water

The ideal brush to create light sparkling on water is the hake, and the secret is lightness of touch and speed of stroke. This technique is most satisfactory when used on Not or rough paper. What you're aiming to do is just touch the high points of the paper with the brush, leaving the indents free of paint. It is the white paper which produces the apparent sparkle. Get yourself a pile of scrap paper and try this over and over again.

Sunsets

There is no doubt that evening skies provide some of the most beautiful effects to be seen in nature. Sunsets, though, need to be tackled with discretion. No matter how gaudy the actual sky appears, it simply won't look believable in a painting. Remember, you or someone else may be looking at the picture for many years, and gaudiness soon palls.

Mixing various combinations of Crimson Alizarin and Lemon Yellow wet-into-wet near the horizon is very effective in suggesting a sky at sunset, and you'll see this illustrated here. Possibly the most important rule is to put in all the subtle colour variations in the sky before indicating the cloud formations on top, in stronger colour.

Sunsets can be at their most effective when combined with water or snow. The reflected sky colours will provide both harmony and unity in any scene.

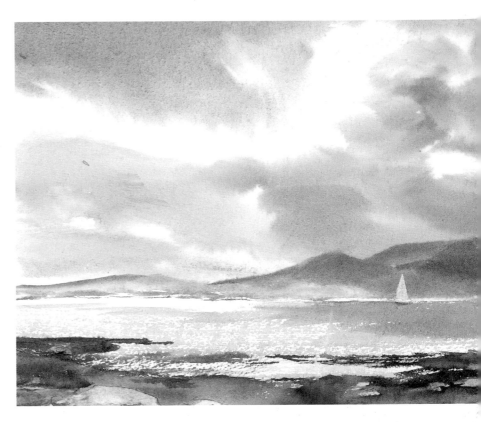

▲ A Morning Sail
23 x 31 cm (9 x 12 in)
The secret of creating sparkle on the surface of water is to work quickly and lightly, preferably with a hake brush.

◄ Severn Estuary at Sunset
23 x 33 cm (9 x 13 in)
I first painted a graduated wash on the sky, adding a mixture of Crimson Alizarin and Lemon Yellow at the bottom. Later I put in the clouds, made up of Payne's Grey and Crimson Alizarin. The sky colour also appears in the landscape below.

Skies and Water

◀ **Misty Morning on Williamette River, Oregon**
29 x 38 cm (11½ x 15 in)
Painting a wet-into-wet scene like this one, in which the sky and scenery are reflected in still water, is great fun. Make sure that the reflections, though softer than the surroundings and objects such as the boat, are about the same shape and tone.

If painting skies can be an exciting and fulfilling exercise, then combining them with areas of water can be doubly so. What's more, there is plenty of water around – after all, about seven-tenths of the surface of the earth is covered by it.

However, if water doubles the excitement, it can also double the challenge to the artist, especially as its character can vary from a still pond or lake to a fast-flowing stream or foam-flecked sea. Still water can act as a mirror, giving an almost perfect reflection of the sky and everything above it, whereas moving water, with its very different mood, has its own special requirements.

Still water

Being without colour itself, water will reflect the forms and colours around it beautifully. If there is nothing else around it, then the water will reflect the sky. When you repeat the sky colours in the water, you will be creating harmony in your painting, as the blues, greys, mauves, or even pinks and yellows of the sky are echoed in the water below.

Even if the sky is all one colour, don't forget that you must graduate the wash you lay down for the water, just as you have for the sky. The water in the foreground should be darker, getting lighter as it reaches the horizon.

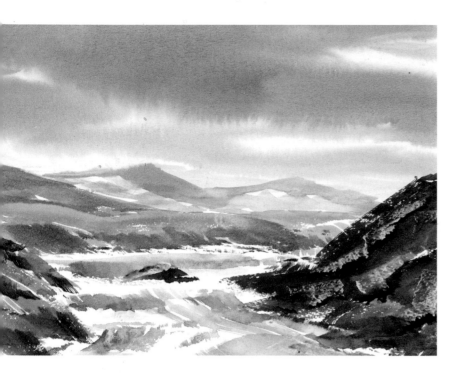

▲ Highland Stream
25 x 35 cm (10 x 14 in)
My objective here was to create the illusion of rapid movement in the water. You can see how much paper was left white while the paint was put on with very fast strokes in the direction of the water flow.

Moving water

Moving water requires a completely different painting technique. To indicate areas of foam and spray, you'll need to leave a lot of the white paper untouched (see page 45). The strokes that you do put in must be worked quickly, following the direction of the water flow. Fast-moving water will give back very little in the way of reflections, except for the basic surrounding colour.

Reflections

Reflections are a wonderful way of bringing unity into your painting, as they repeat the colours and shapes of surrounding objects, such as buildings, trees or posts. Remember that if an object is situated right at the edge of the water, the reflection will be the same size, but if it is further back the reflection will be shortened.

To depict reflections in an expanse of still water, begin by painting the water itself, using horizontal strokes to put in a graduated wash of the main colour used for the sky. You'll find that the hake is an ideal brush for this. While this first wash is still quite damp, put in the reflections with vertical strokes, compensating for the water already on the paper by using rich paint. The reflections will soften a little due to the water content of the paper, but because of the rich paint, the basic colour and shape will remain true to the reflected object.

▶ Tranquil Evening
23 x 31 cm (9 x 12 in)
After painting in the sky, I first indicated the river by using the sky colour above it, and then added the reflections of the trees while the first wash was still wet. Notice how the dark cloud and the group of trees balance each other.

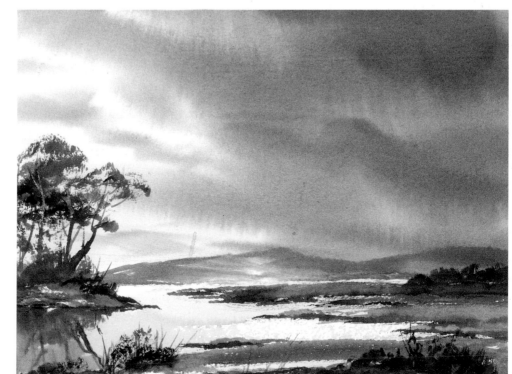

Completing the Painting

Every sky painting needs a foreground, however minimal, to give it scale and impact. But it is important that the two parts of the picture are completely integrated to provide unity between them. You can achieve this in several ways – by repeating the sky colours in parts of the landscape; by linking the land to the sky by placing a vertical element on the horizon, rather like a piece in a jigsaw puzzle; or by echoing the shape of one object with another, perhaps a rounded cumulus cloud with a tree. The shadows of racing clouds on the ground can provide another effective link between the upper and lower areas of a painting.

Generally, when you are working on a sky painting, you have only got about 5 cm (2 in) of space at the bottom of the paper to convey a landscape that in reality goes back for miles. So you'll need to exploit your knowledge of aerial perspective to the utmost (see page 32). For example, you could put in distant hills with a flat grey-blue shade, warming up the colours gradually as you move towards the front of the painting and confining any textural details to the foreground.

▼ **Late Afternoon, Norfolk Broads**
29 x 38 cm (11½ x 15 in)
The closest trees, which link the land to the sky, were painted with a rigger and some dry brush work with a hake. The ground is mainly a warm mix of Light Red and Raw Sienna, and the water contains the same colours as the sky to provide unity.

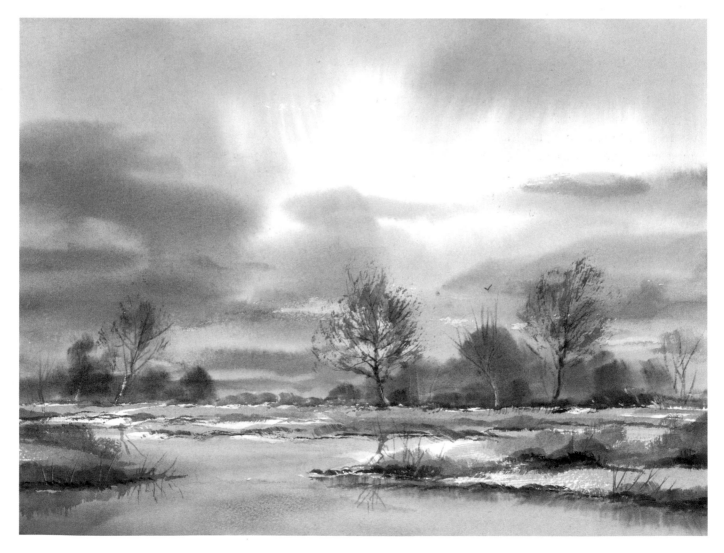

Texture in the foreground

One of the main mistakes to avoid in your watercolours is to ruin a lovely fresh sky, which of necessity must be painted quickly and courageously, by producing a muddy, overworked landscape below it. Tall grasses and reeds are probably the most commonly used, and overworked, foreground subjects, whether the scene is a grassy field, a river bank or a forest floor. However, these seemingly impossible masses of vegetation can easily be symbolized. Rocky ground, too, can be suggested with just a few brush marks.

For instance, take woodland undergrowth, a grassy field or some rocky ground that starts at your feet and goes back into the distance. Much of this can be left plain and uncluttered. All the real textures can be confined to the absolute foreground, quickly disappearing to almost nothing as the ground recedes.

To create a grassy foreground texture, lay down an overall wash first and then, with a rigger, put in a few blades of grass to reach about halfway back to the horizon. These will soften and become out of focus. As the paint becomes slightly less damp, indicate a few light blades of grass with your fingernail. Finally, use a corner of the hake with some rich paint to suggest some more foreground features, such as small stones or rocks.

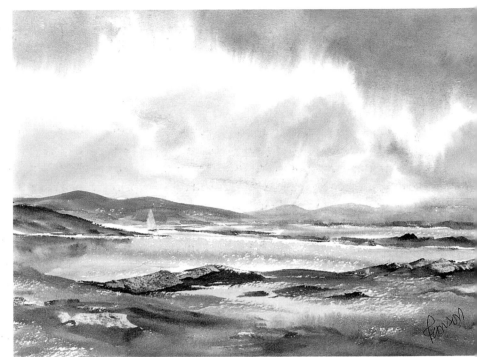

▲ The Mauve Hills
31 x 41 cm (12 x 16 in)
To create texture, a dry brush technique was used on top of the initial colour wash after it had dried.

▼ Grasses, stones and rocks are useful for creating textural interest in the foreground of a landscape, but make sure that you paint them simply and economically. Just a few brush strokes can symbolize a mass of different features.

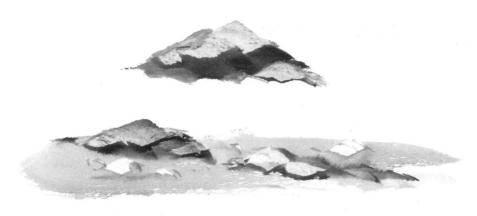

▲ These rocks are given
a convincing solid form
by using a light tone on
the tops and dark shading
on the sides.

▶ Notice how the sky is
visible through the gaps
in the foliage of this tree.

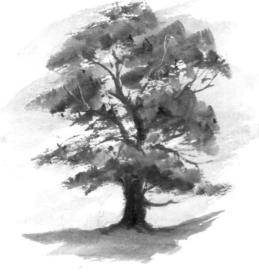

Specific landscape features

Large foreground rocks often feature in
country landscapes, so the ability to portray
them authentically and with simplicity is
essential. The secret is to make them look as
solid and heavy as possible. Remember that
the top of a rock, as it faces the sky, will be
much lighter than the sides, which are in
shadow and are therefore darker. By painting
rocks in this way, you will give a convincing
impression of their heaviness and solidity.

Trees, too, are a prominent feature of many
landscapes, and will help you to connect and
unify the sky with the land in your painting.
When you paint a tree over the sky, leave
plenty of gaps in the foliage, otherwise it will
tend to look like a toffee apple – and the birds
need a way through! Another tip: don't leave
a space in your initial sky wash to anticipate
a tree to be put in later – you will always need
the sky colour to show through.

▼ This scene shows
trees at three different
distances. The background
hill, although completely
wooded, is treated as a flat

colour. The trees in the
middle distance are very
loosely indicated and only
the foreground trees are
given some detail.

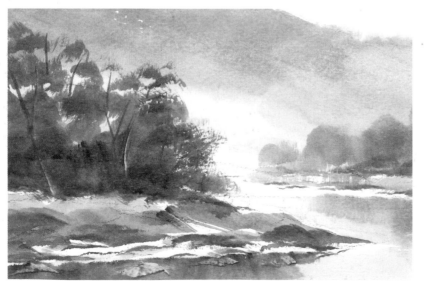

▲ Nearby trees always
appear stronger and
richer than more distant
ones. You'll see that the

tree on the far left, being
further away, is cooler and
flatter than the large one
in the foreground.

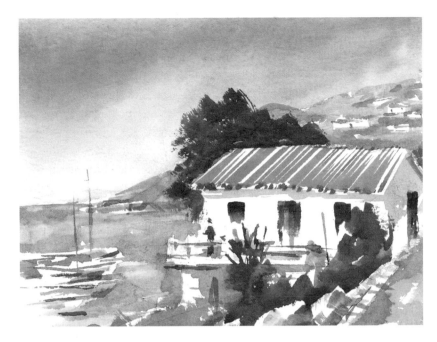

Buildings

There will be times when your skyscapes will benefit from simple buildings beneath them. For instance, a sharp-edged barn could be used to balance a heavy cloud on the other side of a painting. A 25 mm (1 in) flat brush is excellent for indicating simple roofs with an economy of stroke.

A useful device for creating a main object of interest in a landscape is to set a white house against a dark tree. Painting a church tower with a few roofs around it is a perfect way to indicate a village. Boatyards and yacht basins, too, provide distinctive features in skyscapes. All that is required to indicate a mast in the distance is a single touch of the 25 mm (1 in) flat.

Don't be afraid of buildings. The more economically they are painted, the better they look, and their sharp edges act as a good foil to the softness of the sky.

▲ **On the Island of Hydra**
18 x 25 cm (7 x 10 in)
The roof tiles on this Greek house are indicated with the edge of a flat brush. The distant village is put in with even more economy.

► Here you can see how buildings can be added to a landscape to create foreground interest. These houses were painted very simply, using a 25 mm (1 in) flat brush.

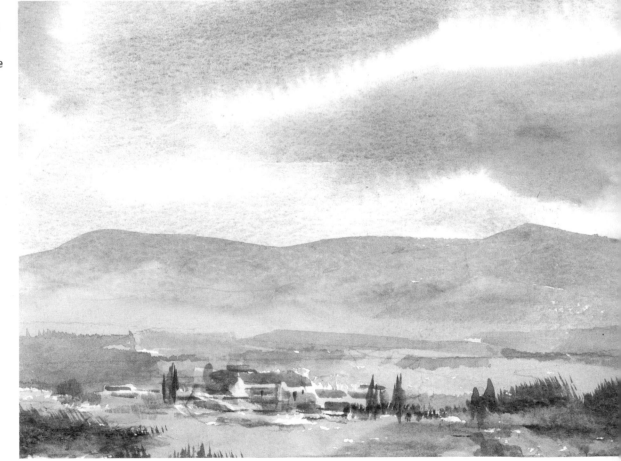

River Valley

This favourite site is very near my home and I'm unlikely to be disturbed while painting on the river bank. The hills on both sides are covered with trees, so the scene changes dramatically with the seasons of the year. In this summer view, the landscape is set against a cloudless blue sky.

▶ First stage

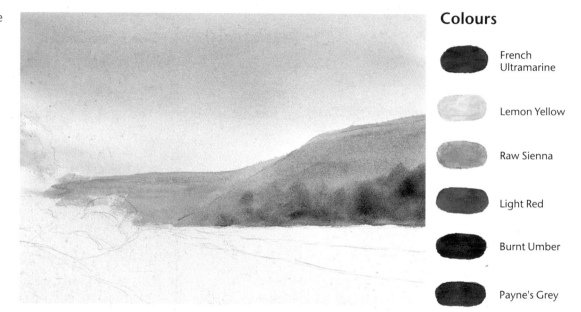

Colours

French Ultramarine

Lemon Yellow

Raw Sienna

Light Red

Burnt Umber

Payne's Grey

First Stage

For this painting, I chose a 300 gsm (140 lb) Bockingford paper with a Not surface. First, I outlined the scene using a 3B pencil. Then I put a very pale wash of Raw Sienna over the sky area with my hake brush. While this was still wet, I made up a rich wash of French Ultramarine. Using a whole arm movement and moving backwards and forwards across the top of the sky, I gradually worked down towards the horizon with the Ultramarine, reducing pressure until the brush was just touching the paper at the horizon. With the paper tilted at an angle of 45 degrees, this produced a graduated wash.

When the sky was dry, I began on the hills. Using a mixture of Ultramarine and Lemon Yellow, I painted in the whole hillside. I then blended a strong mixture of Lemon Yellow and Ultramarine into the right-hand hillside to bring this area forward. While this was still wet, I mixed a very strong Payne's Grey and Lemon Yellow and painted a line of trees in front of the hill, using a corner of my hake.

Second Stage

With a mixture containing Lemon Yellow and just a touch of Ultramarine, and using the hake horizontally, I put in the right-hand field. Next came the river bank itself. I used diagonal strokes to portray its slope, adding touches of Light Red and Raw Sienna with darker accents made from a mixture of Ultramarine and Burnt Umber. Moving

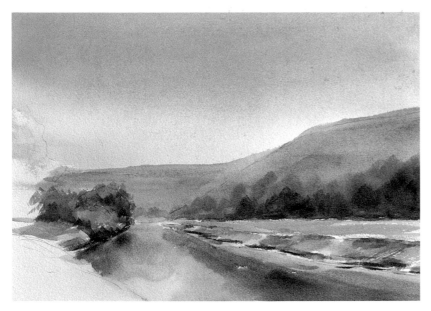

▲ Second stage

▼ **River Valley**
25 x 35 cm (10 x 14 in)

across to the left-hand trees, I painted these with a corner of my hake, using Payne's Grey and Lemon Yellow.

For the river, I put on a very wet wash of Ultramarine. Then, making up a strong, rich mixture of Payne's Grey and Lemon Yellow, I dropped in the reflection of the hillside on the right and the tree on the left, making sure that the reflections were not too anaemic.

Finished Stage

While the river was still damp, I wiped out two white streaks on the water with a dry hake brush (see page 19) to indicate a wind-ruffled patch of water. Once those were in place, I concentrated on creating the foreground on the left-hand side.

I painted the bank in the foreground in a mix of Raw Sienna and Ultramarine to bring it forward. Finally, I put in the large tree on the left and the foliage on the river bank below it with a rich mixture of Lemon Yellow and Ultramarine.

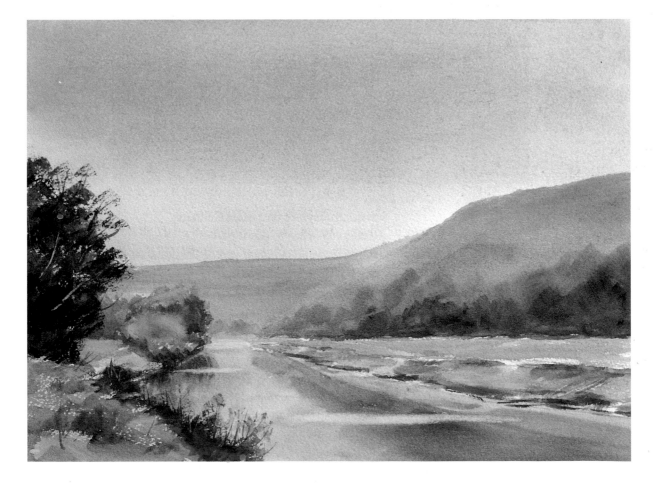

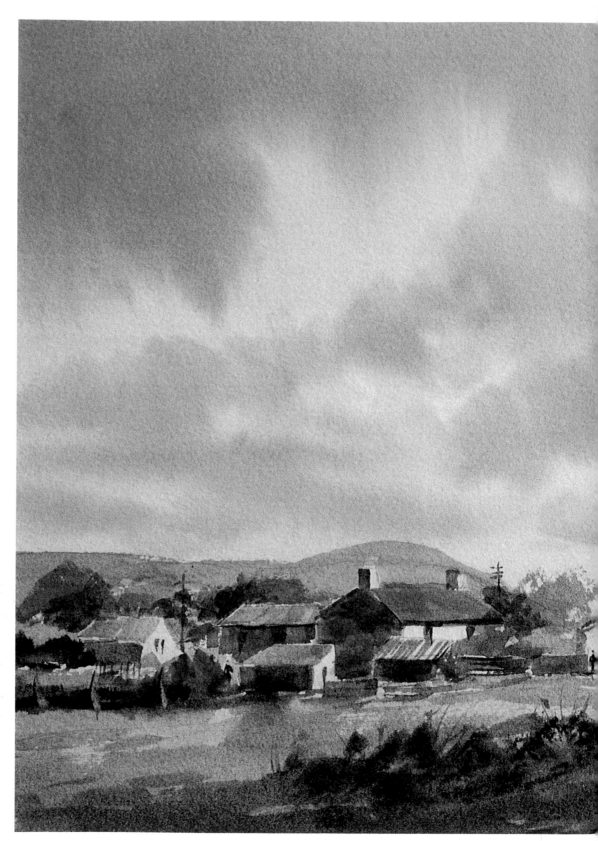

▶The Road to a Village
31 x 41 cm (12 x 16 in)

Finished Stage

I felt that the picture would be made more exciting by looking from foreground shadow into a sunny field before reaching the village. The shadows were caused by trees on the right, just out of the picture. The shadow colour was made up of Light Red and Ultramarine, and I put this in with a quick, light sweep of the hake, using a whole arm movement. I left one or two sunny streaks among the shadows. Finally, I added fine grasses in the foreground with the rigger, using the same mixes as for the bushes in the previous stage.

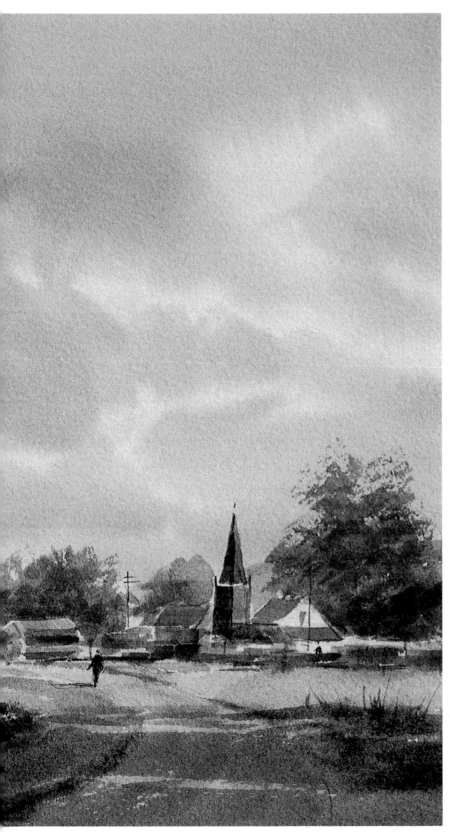

▶ Detail of finished painting

Sunset on the Estuary

This river estuary is another favourite painting spot within a short distance of my home. The best time to paint there is at low tide, when the sky is reflected off the wet sand. The pink and yellow colours of the sunset and the grey streaks of the clouds make this a very dramatic picture, especially with the dark silhouettes of the moored yacht and the posts in the foreground.

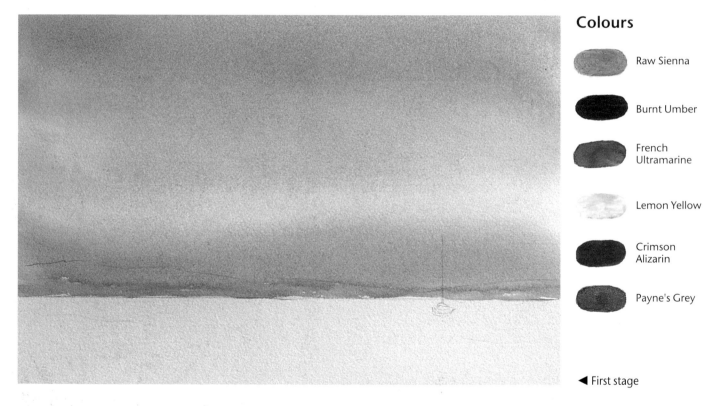

Colours

Raw Sienna

Burnt Umber

French Ultramarine

Lemon Yellow

Crimson Alizarin

Payne's Grey

◄ First stage

First Stage

After establishing a flat pencil horizon on a piece of Bockingford 300 gsm (140 lb) Not paper, I indicated the moored yacht on the right. Using a hake, I painted a very pale Raw Sienna wash over the whole sky area. I then put in a graduated wash of Ultramarine from the top and, quickly washing out my brush, painted a strip of Lemon Yellow two-thirds of the way down. Adding Crimson Alizarin to this wash, I painted the bottom of the sky. If you do all this while the original Raw Sienna wash is still wet, all the colours will blend as they have here.

Second Stage

Next I tackled the clouds. For these, I had to use thicker paint in a blend of Payne's Grey and Crimson Alizarin. There was no time to be hesitant – I had to put them in boldly and quickly, using my whole arm to make these strokes across the paper. The fact that the sky wash was still slightly damp meant that the clouds softened and blended.

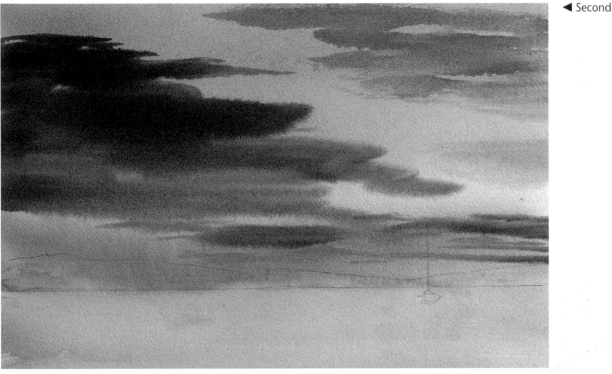

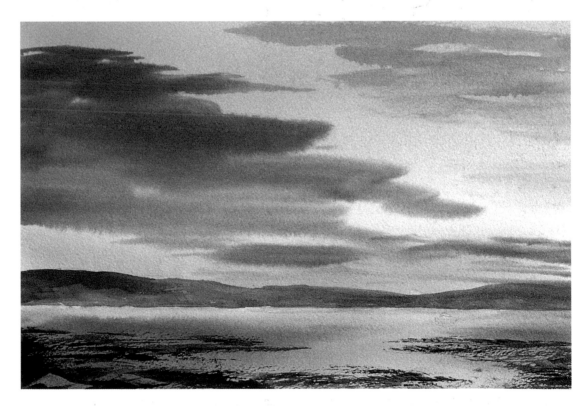

Third Stage

When the sky was dry, I painted in the land on the horizon with a mixture of Payne's Grey and Crimson Alizarin. Once this had dried, I rendered the water of the estuary in Lemon Yellow, Crimson Alizarin and Ultramarine.

My aim here was to mirror the sky as much as possible. When this, too, was dry, I put in the rocks and beach. I varied the mix here with Ultramarine, Burnt Umber and Raw Sienna, using the dry brush technique (see page 18) with the edge of the hake to provide texture.

Finished Stage

I added the various posts on the left and in the centre, as well as painting the moored yacht – this wasn't actually in the scene in front of me, but became the focal point of the whole picture. These details were put in with a mix of Burnt Umber and Ultramarine, using a 25 mm (1 in) flat brush.

▶ **Sunset on the Estuary**
31 x 41 cm (12 x 16 in)

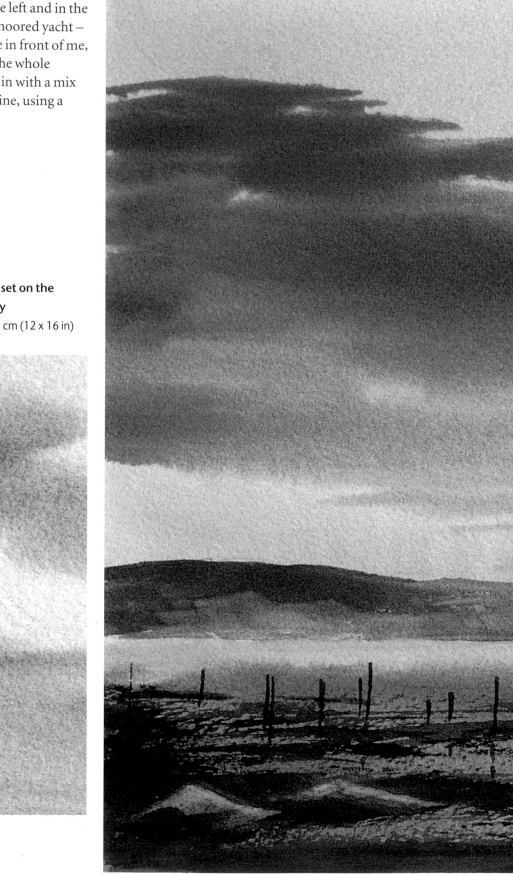

▲ Detail of finished painting

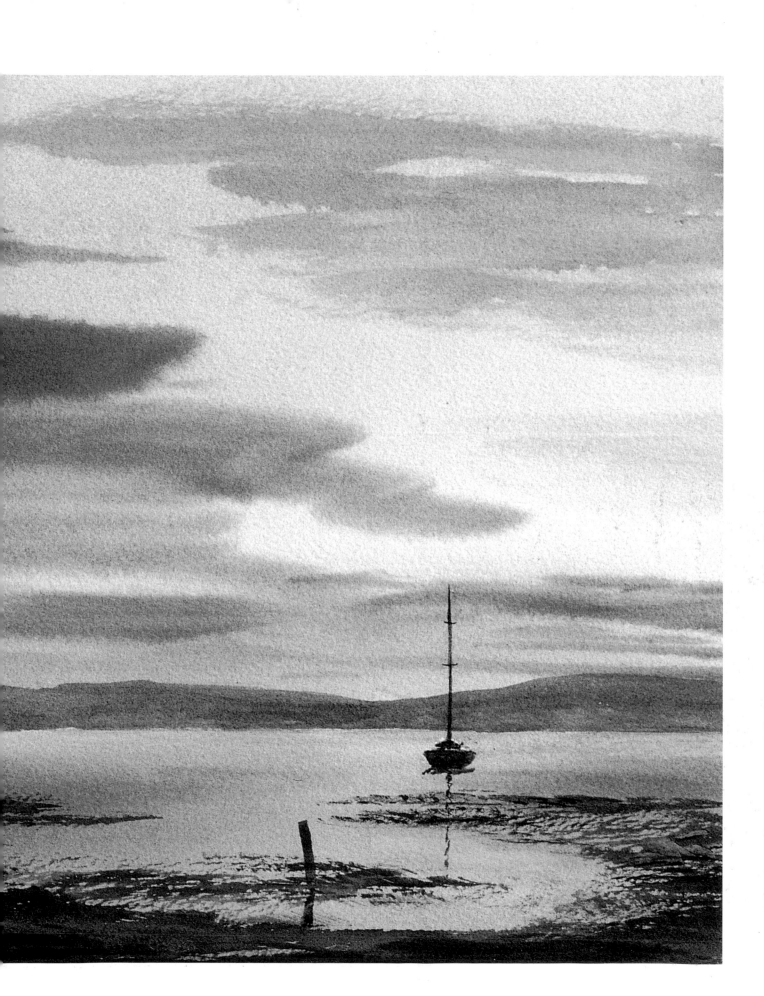

A Winter Landscape

I have always enjoyed painting in the Lake District. However, the weather is variable to put it mildly, and I've often seen this type of cloud formation over the mountains. A stormy sky like this is much simpler to paint than one with cumulus clouds.

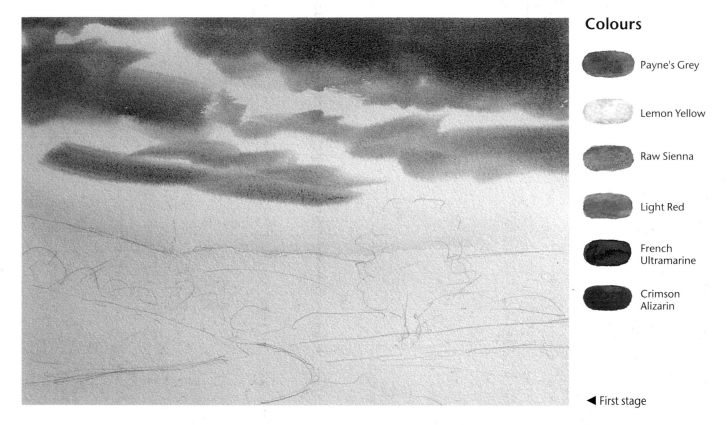

Colours

Payne's Grey

Lemon Yellow

Raw Sienna

Light Red

French Ultramarine

Crimson Alizarin

◄ First stage

First Stage

After drawing out the scene as a whole in 3B pencil on a 300 gsm (140 lb) Bockingford Not paper, I dampened the whole sky area with a wash of very weak Raw Sienna, adding a little Lemon Yellow just above the hills. Next, I mixed a strong solution of Crimson Alizarin and Payne's Grey, and while the original wash was still damp (this is very important), I danced my hake brush right across the top of the page. Leaving gaps in between, I produced several more clouds, gradually reducing their size as I moved towards the horizon.

Second Stage

After the sky area was dry, I put in the distant hills with Raw Sienna, Crimson Alizarin and Ultramarine, adding a paler mix using Light Red on the left. I then painted the fields with Raw Sienna and Light Red in various mixes.

Third Stage

Having completed the fields, I started to add trees to the scene, using Ultramarine, Crimson Alizarin and Light Red quite strongly. I was creating a warm blend of colours here to establish harmony in the

► Second stage

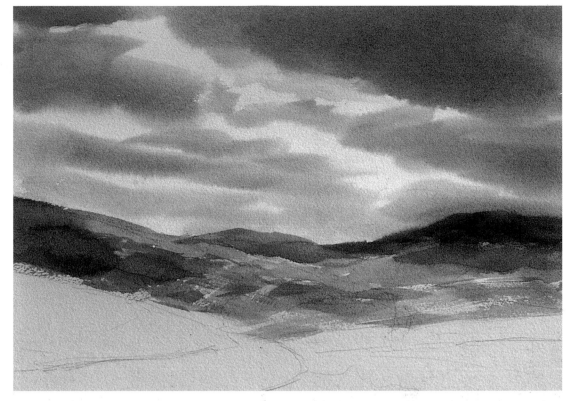

◄ Third stage

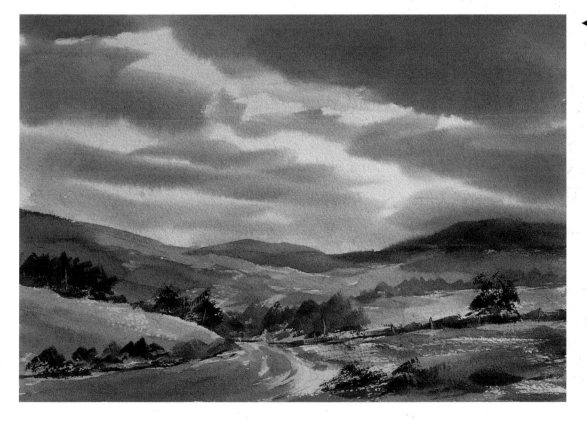

painting. I also repeated some of the sky colours in the landscape for unity.

I put in the road, using directional strokes of the hake with Light Red and Ultramarine on top of a previous wash of Raw Sienna. With my fingernail, I scratched away the paint to indicate pale posts and tree trunks, and I then changed to the rigger to add foreground bushes.

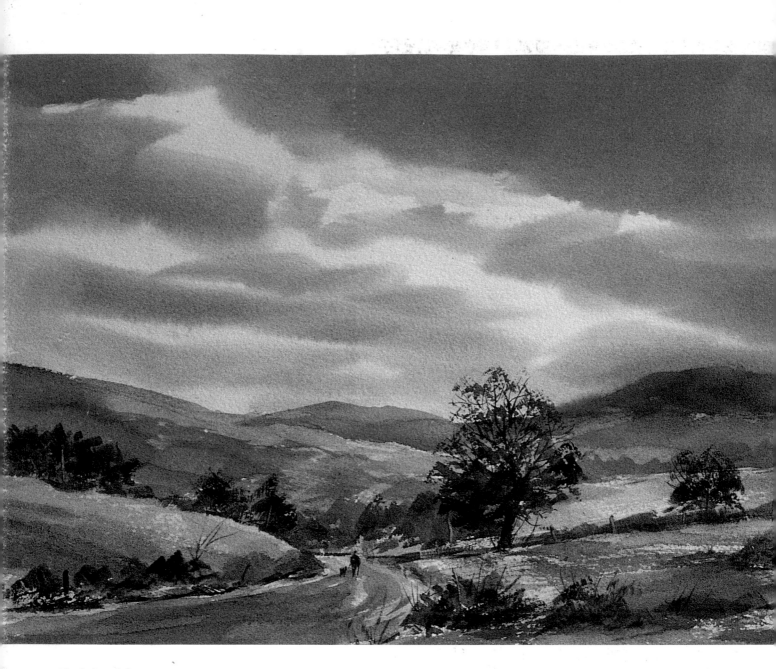

Finished Stage

I now decided to put in a main tree and a figure with a dog. For the main foliage of the tree, I dabbed on a rich mix of Ultramarine and Light Red with the back of my hake, leaving gaps to which I added branches with the rigger. I also used the rigger to indicate the walking figure with the dog, and some fine grasses in the foreground.

▲ **A Winter Landscape**
31 x 41 cm (12 x 16 in)